CONSTABLE

GIUSEPPE GATT

D0956714

THAMES AND HUDSON

Translated from the Italian by Pearl Sanders

This edition © 1968 Thames and Hudson Ltd, London
Copyright © 1968 by Sadea Editore, Firenze
Copyright © 1980 by Scode, Milano

Published in the United States in 1989 by Thames and Hudson Inc.,
500 Fifth Avenue, New York, New York 10110

Library of Congress Catalog Card Number 89-50734

Printed in Italy

Life

John Constable was born on 11 June 1776 in the village of East Bergholt, Suffolk. This is some of the richest and most fertile farming land in England, and its beauty was always to be a source of delight to the artist. He once said that it was due to the strength of his early impressions of this part of the country that he became a painter.

His father was a prosperous mill-owner in Dedham Vale, and wanted his son to follow the family tradition. However, in the face of Constable's firm resolve to become an artist – although at that stage he showed little promise – his father finally allowed him to go to London and attend the Royal Academy school (1799). Here, under the guidance of the painter Joseph Farington, he learned the secrets of Richard Wilson's technique.

The most important event of this period was his introduction to Sir George Beaumont, an amateur painter and art collector, who showed Constable the famous paintings in his collection: Rubens, Ruysdael and Claude's *Hagar and the Angel*. Claude had a determining influence on the development of his painting, especially as regards composition. Beaumont also lent Constable some of Girtin's watercolours and suggested that he should copy them as an exercise. (From this close contact with Girtin's work, he developed the broad manner of landscape painting first apparent in the landscapes of 1809.) Another exercise was to make a careful copy of a painting by Ruysdael which he had managed to buy with the help of Richard Reinagle, an artist with whom he shared a home in London.

All these circumstances combined with his natural inclination to make Constable almost exclusively a landscape artist, following either the direction of classicism (Claude, Poussin, Dughet) or of Dutch and Flemish art (Rubens, Ruysdael). The English painters who most influenced his youthful work were Richard Wilson, Turner and Gainsborough: 'I fancy I see Gainsborough under every hedge and hollow tree', he wrote in 1799 from Ipswich.

In 1801, following a practice which was usual among artists of the time, he spent some time travelling about the countryside. He visited Derbyshire several times and brought back a number of watercolours. In 1802 he took part for the first time in the Royal Academy exhibition. In the following year he travelled by sea from London to Deal, where he painted some seascapes.

Though the first commission he received was for a landscape, during the early years of his career Constable was not specifically a landscape artist, partly because this type of painting was not fashionable at the time. He had to accept commissions to copy paintings by Reynolds, to do religious works (the two altar-pieces for Brantham Church) and portraits inspired by Lawrence and Reynolds – these showed excellent craftsmanship and were, incidentally, highly remunerative.

When at the age of thirty Constable visited the Lake District, he was so depressed by the winter storms over the mountains that the whole orientation of his painting became directed towards landscapes of serene harmony. So that while Turner found mountain storms a recurring source of inspiration throughout all his work, Constable focused his interest on the harmonious and pleasant aspects of the places most familiar to him: Hampstead, Salisbury, Suffolk, Brighton.

Constable was convinced that his true vocation lay not so much in seeing new places and gathering unusual impressions as in making a deep and patient study of nature, with a profound respect for the values enshrined there. Soon afterwards, the poetry of Wordsworth was to reflect a similar attitude to nature.

In 1809, at the age of 33, Constable met the granddaughter of the Rector of East Bergholt, Maria Bicknell. He fell in love, but her parents strongly opposed the marriage, as they were of a social class superior to that of a miller's son. To try to forget his disappointment, he withdrew into the country and devoted himself entirely to his painting: among other things, he filled two sketchbooks with watercolours and drawings, to which he later returned. It was only after the death of Maria's parents that they were

able to marry. There followed twelve years of success and creative activity.

In 1811 Constable was a guest of the Bishop of Salisbury, and formed a close friendship with the bishop's nephew, John Fisher. It was at John Fisher's house, in Osmington, Dorset, that he spent his honeymoon, and here he painted his first important seascapes, including the famous *Weymouth Bay* (*pl. 24*).

From 1817 onwards he painted a large work for the Royal Academy exhibition every year. In 1819 (from this year until 1825 was the most creative period of his career) he was elected an associate member after showing *The White Horse*, a painting he described as one of his most successful works. However, it was not until he reached the age of 53 that he was elected to the Academy, and then the President, Sir Thomas Lawrence, did not fail to point out that as

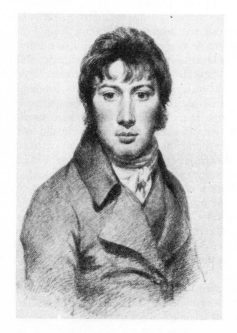

Self-portrait, c. 1800
(*see p. 25*)

a landscape artist he must consider himself fortunate to be given preference over artists of greater merit and talent.

It is a well-known fact that Constable did not submit to official exhibitions the works which expressed his deepest feelings. He hoped in this way to be well thought of by the public and critics. Many of his paintings exist in two versions: a sketch, which he considered his true creation, and a finished work to be sent in to exhibitions.

Constable's first international successes came to him in France, in the Paris Salon of 1824. In an exhibition organized on the initiative of Bonington, his works were admired (King Charles X conferred a gold medal on him) and became a source of inspiration to many contemporary French artists, including Delacroix – who was said to have repainted the *Massacre of Chios* after seeing Constable's work – and later artists, such as Pissarro.

In spite of Constable's success – he had by now become one of the greatest influences on the art of his time – he never went to Paris or wished to leave England. He was completely indifferent to the traditional ' grand tour '; in the Suffolk valleys where he was born, in the wide and rainy spaces of Hampstead Heath, he found the authentic and unique source of his inspiration. It is in this irremediable Englishness of his that Shirley saw one of the fundamental contrasts with his great rival, Turner, who was always eager for travel, for new experiences and sensations which could be translated into his painting. Not that Constable did not on occasion experience a longing to see Italy, for he once wrote that he was doomed never to see the living scenes that inspired the landscapes of Wilson and Claude.

Meanwhile, he continued to produce numerous studies of the landscape of the Stour Valley. In 1823 he painted the first version of *Salisbury Cathedral* (*pl. 34*), a composition which was to have a very important effect on his future work. In the same period he made meticulous studies of skies and faithfully rendered the most fleeting changes of mood and atmosphere.

In 1824 he moved south to Brighton, where he was able to paint many seascapes, one of his favourite subjects. He made a detailed study of Claude (who had brought landscape

art to perfection) and the Dutch school: Cuyp, Ruysdael and Hobbema. He never stopped learning from Rubens and Rembrandt.

Constable's vision of the world was new and original, without sublime or terrible moments, anti-dramatic and anti-scenographic, and on the whole rather bourgeois. As C. R. Leslie has said, his ' John Bullism ' is often pushed too far.

Constable's wife had been suffering from tuberculosis for many years, and it was for the sake of her health that they had gone to live in Brighton. In 1828 she died, leaving her husband and seven children heartbroken. In spite of this great loss, Constable's output was scarcely affected. In fact, he took refuge in art, though the grief which was never to leave him showed itself in his paintings, as their composition became more disturbed and restless, their tonality gradually darkened, and an element of rhetoric crept in.

After 1828 he painted no more portraits, but only landscapes. The main reason for this was that his wife's legacy enabled him to refuse commissions not of his own choosing. In 1830 he issued *English Landscape*, a series of mezzotint reproductions of his paintings, executed by David Lucas, certainly with the intention of rivalling Turner's *Liber Studiorum*. The preface to this work may be considered both his theory on his own art and on art in general. The work is animated by the same spirit as the paintings: a passionate desire to make the beauty of rural England known and appreciated.

In 1835 Constable gave a series of lectures on landscape painting at the Royal Institution in London, which are of great importance to an understanding of his theories of art. In the same year he gave a course of lessons at the Royal Academy of Art. Meanwhile, he gradually abandoned the ' non-finished ' manner and strove for an ever greater degree of ' finish '.

On 31 March 1837 Constable died at the age of 61. His shy and reserved character had prevented him from making many friends. Despite his success, he had avoided the brilliant English society of the day and chosen a quiet, domestic life, always close to the beauty of the English countryside. He worked unceasingly and was never made proud by success.

Works

Nineteenth-century art cannot be fully understood or appreciated unless account is taken of certain fundamental artists, Constable among them. Besides being the chief exponent of the type of painting known as 'picturesque', he was responsible for removing the deeply rooted prejudice which insisted that the function of art was to represent man, since by its nature art was 'the work of man'. Constable chose instead to devote himself to landscape painting, almost to the exclusion of all other forms of art, and it was in landscape that he sought the values of man.

The artistic background against which Constable's art came to maturity was that of eighteenth-century England: influenced by the Italian, Flemish and Dutch traditions (thus completely free from the neo-classical trend which was conditioning the art of Europe during the same period) and modelling itself on Salvator Rosa for dramatic landscape, Claude for an idyllic view of nature, Poussin for a classical and 'sublime' view, and to a certain extent also on the Italian scenic paintings of Canaletto and, as Fiocco has observed ('John Constable', *La Biennale di Venezia,* 4 February 1956), Guardi.

The dominant aesthetic theory was that of Burke who, in 1756, had invented the category of the Sublime (comprising the exciting and romantic sentiments of the 'dramatic' and the 'infinite'), as a counterpoise to the category of the Beautiful (characterized by more serene and domestic elements).

From a close observation of certain landscape paintings, composed of barely sketched-in irregular elements of great liveliness and variety, and from a study of the Italian school (especially Titian), Sir Uvedale Price in 1794 defined a further category, the Picturesque, which was destined to play a pre-eminent part in the history of English painting. This category was mainly founded on a concept of natural 'beauty', as it had already been celebrated in the art of the past (by Venetian and baroque painting) and was to

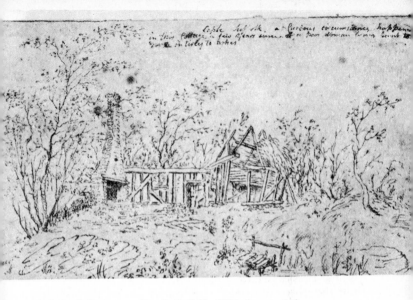

A Ruined Cottage at Capel, Suffolk, 1796 (see p. 25)

become a vehicle and source of inspiration for new visual concepts.

It is undoubtedly from the concept of ' picturesque ' that landscape painting in general came into being, the picturesque acting as a projection on to nature of the idea of the ' beautiful '. And as Constable was a master of landscape art, his is especially a picturesque form of painting; although in this picturesque art he never permits himself any indulgence in decorativeness or in arbitrary and dilettantish effects, and avoids the stylistic exaggerations to which such a concept of art might easily lead. His painting was of an extreme moral rigour, holding firmly to fact, and entirely devoted to the study of truth and nature. One may therefore rightly say that it is in the art of Constable that the ' picturesque ' returns to its original sources, to Titian and Venetian scenic painting: in other words, it becomes ' pictorial '. The type of landscape painted by Constable reflects his aesthetic theories: it is, as we have seen, a familiar landscape, calm, peaceful and sometimes almost domestic; but

in essence it is a typically English landscape, in the same way as the *Lyrical Ballads* of Wordsworth and Coleridge are typically English. The imagination of the artist bows before it in humility and love, and also with that intimate knowledge which only daily use can confer.

In his ever deeper experience of the beauty of rural England, Constable did not concern himself with startling visual innovations; he even showed little interest in the traditional journey to Italy, an obligatory step for all his colleagues. Fiocco compared this proud attitude to the 'stupendous solitude of Rembrandt', showing the same noble independence and firm, yet modest, determination to preserve his integrity.

Lionello Venturi wrote: 'His naturalism is candid, positive, and factual, as unsentimental as painting can be: on the basis of the distinction between candid and sentimental poetry, Constable is to be included among the candid, that is, the classics' (*Pittori Moderni*, Florence, 1949).

But the most surprising fact in connection with Constable's classicism, to which Venturi has drawn attention. is that he succeeded in being a classical artist while painting such subjects as landscapes, which are outside the pure classical tradition (of the Greeks, the Romans and the Italian sixteenth century); and in the early stages of the argument between neo-classicism and romanticism, he was definitely on the side of the romantics and became for them a source of inspiration.

English landscape painting of the period immediately preceding Constable, or of the same time as his youthful works, was not the best basis for the development of his art: the main elements in this painting were the dark, angry brooding of Fuseli, Blake and Francis Towne (directly derived from Ossian's poetry), the heroic idealism of Reynolds, the dramatic and tempestuous scenic painting of Loutherbourg and George Morland.

An exception – greatly prized by Constable – was the painting of Alexander Cozens (especially his early watercolours). Others who, like Constable, wished to react to the artistic heritage of the past were, in their different ways, Girtin and Turner: the former through a calm and

constant analysis of landscape values expressed without trace of classical or Flemish influence, but only through the personal intuition of this subtle landscape painter; the latter through his extraordinary capacity to bring Claude and Wilson up to date, and enable them to merge in the infinite range of new visual concepts.

In his approach to natural reality, Constable was not so much concerned to achieve knowledge through nature as to discover and get to know nature itself, for what it is and what it can give and teach. This humble attitude caused him to make a close and analytical study of nature throughout his life.

'Few painters had Constable's power to bring the infinite facts of nature into one single pictorial idea and, with almost unconscious naturalness, to translate them into a poetic image', wrote Attilio Podestà ('Retrospettive dell'ottocento', *Emporium*, No. 667, 1950).

Chiaroscuro was a basic theme of Constable's art. For him the 'chiaroscuro of nature' was not only a general view of landscape as it was affected by the way light fell on objects, but a reflection of the most fleeting aspects of reality, the succeeding of sunrise to dawn, of evening to twilight; the thousand fascinating and evanescent moments which must be caught and held before they disappear into the next impression. This preoccupation was to be the nucleus of the art of the impressionists.

This principle meant that, at least in his greatest works, Constable hardly ever made a selection of certain aspects of nature; he loved nature in its entirety, not according to the canons of an abstract concept of beauty (terrible, sublime, picturesque or classical) but for the wonderfully changing manifestations of its visual values. This is perhaps why – as Fiocco wrote – 'Constable... brought to a close the long story of the eighteenth-century affiliation with Venice '.

It is in this aspect that the scientific, or rather, 'illuministic' character of Constable's painting is to be understood, as a distrust of the imaginative faculty and a close adherence to the phenomena and facts of nature: the task of the painter, he wrote, is 'a pure perception of the natural fact'.

In this way he transformed the emotion experienced in the presence of nature into a scientific classification of the observed data, so that his spontaneous emotion became controlled by the intellect. Nature also exercised a religious fascination over Constable: a typically English phenomenon. In 1819 he wrote to his wife: 'Everything seems full of blossom of some kind and at every step I take, and on whatever object I turn my eyes, that sublime expression of the Scriptures, " I am the resurrection and the life ", seems as if uttered near me.'

The very way the hours of the day are marked out is based not so much on a realistic or practical arrangement as on an almost mystical respect for the marvels and variety of created life: 'The world is wide: no two days are alike, nor even two hours; neither were there ever two leaves of a tree alike since the creation of the world; and the genuine productions of art, like those of nature, are all distinct from each other.'

Constable's attitude to nature affected his choice of subject-matter, for a close study of the individual phenomenon implied the abandonment of scenic and panoramic views in favour of a concentration on the particular aspects of nature which in microscopic form reveal the beauty and mystery of the universal macrocosm. It meant also that his attention had to be focused on the variations undergone by that individual part of nature under the action of light and shade. In this way Constable participated fully in the life of nature, without indulging in flights of fancy or romantic mannerisms: his paintings merely express light, dew, fresh breezes and blossom. Nothing of all this, he declared, had ever been painted before by any other artist in the world. The great was not for him, he wrote, nor he for the great; his 'limited' art was found in every path, and whatever one might think of it at least it was his own. He would rather 'have the smallest thing of my own', even if only a hut, rather than live in someone else's palace.

In these terms Constable explicitly renounced grandeur, the sublime, and the unusual and startling innovations desired by the romantics; he renounced also the calm, abstract measure of the classic. At the same time, he wished to be

completely free from the schematic effects of mannerism, and in fact argued vehemently against the theories of the mannerists: if they had never existed, painting would always have been easily understood. It was this seriousness of purpose which enabled Constable to judge correctly the art of the eighteenth century; this was something Bonington was never able to do, in spite of his greatness as an artist, and his enthusiasm for the festive century must have appeared excessive and frivolous to Constable.

However, it becomes immediately obvious that, in spite of his firm intention to paint in a realistic manner, untouched by the theories of the romantic movement, there were occasions when his painting became decidedly romantic, and these occasions were by no means infrequent. They probably arose out of an over-emphasis on reality, taken to such length that it ceased to be reality at all and became a romantic exaggeration of it. As Venturi has pointed out, ' we see in the artist two natures; the meticulous, diligent, tenacious realist, without flights of imagination, and the exalted, monumental romantic. When one of these two natures predominates, the artistic value declines or disappears altogether. But when they coincide, and the realist is carried away by his imagination while the romantic is present and acts through the realist, then masterpieces are born. '

And it was with reference to that indeterminate state of uncertainty between one nature and another, one vocation and another, between realism and sentiment, found so frequently in the work of Constable, especially after 1819, that Arcangeli spoke of a limbo in which Constable's painting remains inexorably confined (in an essay on the great retrospective exhibition of Constable's work at the 1950 Venice Biennalè, ' Il limbo di Constable ', *Paragone*, No. 11, November 1950). We might find his judgment too severe, but he writes as follows: ' Because during the most creative years of his career, from 1819 to 1825, he had striven to bring painting on to a plane of greater sincerity, he could no longer attain grandeur in the works which receive the greatest prestige. A limbo awaits him where his shade walks, suspended between the ancient and the modern, just as the figures in Dante's limbo, " neither sad nor joyful ". He was

not so modern as to cause scandal; he was modern enough to please only a few. He was dogged by the shadow of moderate success, perhaps a greater torment than the scorn and total failure which afflicted his greatest followers, the impressionists. He was always under the impression that he had not had enough out of life. '

Before examining in greater detail the chronological development of his art and aesthetic theories, it must be said that his work did not show great changes in style during the course of his not very long career. His style evolved gradually as his technique became freer. We must also consider the difference between his sketches and his highly finished works. He always considered himself a faithful interpreter of nature, although his interpretation, which had begun as realistic, may perhaps be said to have ended as romantic.

Constable's rigorous and methodical study of nature and the art of the past originated perhaps in the difficulty of finding an artistic formula able to fill the void which existed in early nineteenth-century painting. Constable succeeded in filling this void by providing a new natural image, so original in form that it was not able to gain the favour of the public until much later, and so lovingly elaborated throughout his whole lifetime that it came to represent a summit in British painting and one of the most authentic and seminal moments in all nineteenth-century European art.

In the paintings executed about the year 1800, Constable's naturalism came to signify an instrument of a high moral and religious order, made manifest through nature. He wished, above all (in spite of the obvious influence of Dutch painters), to be himself and to avoid any kind of imitation. In 1802, in a famous letter to his friend Dunthorne, he wrote: 'For the last two years I have been running after pictures, and seeking the truth at second hand. I have not endeavoured to represent nature with the same elevation of mind with which I set out, but have rather tried to make my performances look like the work of other men ... I shall return to Bergholt, where I shall endeavour to get a pure and unaffected manner of representing the scenes that may employ me. There is little or nothing in the exhibition worth looking up to. *There is room enough for a natural*

painter. The great vice of the present day is *bravura*, an attempt to do something beyond the truth.'

In fact, in the works of this period, for example, *Valley Scene with Trees*, 1801, *Boats on the Orwell*, 1803 (Victoria and Albert Museum, London) and *Stream, Trees and Meadows* (Sadler Collection), few cultural influences are apparent; the painter's entire attention is given to a faithful representation of nature, where this fidelity is, of course, an originality in style but also, and especially, a respect for an idea of nature as a moral and holy ideal, to be esteemed as a visible manifestation of God's truth.

And because truth may be attained through a continuous and profound contemplation, Constable's religious feelings found immediate release in painting, and were fulfilled in the possession of things and a profound comprehension of their significance, achieved by means of their translation into art. This was a rational process, not only an effect of inspiration, as it was for the romantics and, to a certain extent, for Turner. On the literary plane, a similar attitude originated in Shaftesbury and was followed through to Coleridge by way of Gray, Collins, Thomson and Wordsworth; while from the technical point of view, certain uses of colour and chiaroscuro came to Constable from Gainsborough and from Reynolds, who in his turn had assimilated them from Rubens, as well as from the Dutch landscape artists and Crome the Elder, the founder of the School of Norwich.

It is on these moral and cultural elements that the difference between Constable's painting and that of his ' official ' contemporaries, Lawrence, Romney, Benjamin West, Raeburn, is most firmly based; while a parallel may be traced with Wilson, Cozens, Girtin and Gainsborough, whose examples were responsible for the first mature works of Constable's naturalism.

He, however, wished his closeness to nature to be pure and sincere, untouched by the aesthetic criteria of art: according to these criteria, the composition of a painting had to conform to the Dutch tradition, while the scenography was imprinted with acquired stylistic effects varying between an arcadian licentiousness and a mannered type of tourist

scenery. Constable speaks with a different voice. The polite and graceful gallantries of Gainsborough, for whom nature is a delightful framework or romantic background to a portrait of a member of the nobility, were in Constable's view too overburdened with literary references and too intellectual. The picturesque parkland and pleasant scenery of Gainsborough's works did not directly lend themselves to a pictorial representation such as Constable could achieve by his paintings of locks and mills: as far as possible he tried to avoid generic and manneristic landscapes, and to direct all his attention to the facts of nature as he saw them, supported by an ideology and view of the world that have been – not unjustly – described as 'bourgeois' (A. Podestà).

This is the fundamental difference between Constable's position and that of artists of the first rank working at the end of the eighteenth century, such as Reynolds, Blake and Fuseli: the lowest category among subjects without any interest – as Fuseli defined it – the kind of landscape limited purely to the servile description of a definite place.

Therefore, if Constable's aspiration to become a 'natural' painter brought about a reaction in 1800-05 against the whole rhetorical and cultural climate of the latter part of the century, his painting after 1805 showed the influence of Girtin, in certain narrow, telescopic views cutting through a calm and severe background, and of Turner, especially in his technique of building up the texture with rough, disjointed brush-strokes, often of a summary and superficial kind. We can see how important Turner's influence was by the fact that the journey to Westmorland and Cumberland taken by Constable in 1806 was the journey Turner had made in 1798.

However, the views of Epsom and Malvern Hall, and *Boats on the Orwell* (1808-9) have an atmosphere of greater calm and contemplation, and are less visionary. This was the first time Constable's work had attained such a degree of equilibrium, and from 1810 it had reached complete maturity.

Works such as *View of Dedham (pl. 11)*, *East Bergholt Cemetery*, *A Cart on a Country Road (pls 6-7)*, *Boats on the Stour*, are examples of a kind of landscape painting

which was quite new in the history of European art. In it, nature is seen through the pure eye of an artist who does not need to concern himself with the requirement of making it match art in order to become art: the spectator participates in the day-to-day life of the countryside, with its trees and hedgerows; he finds that he is among them, part of the flow of daily life, in a rural scene which is not 'composed' but extraordinarily universal and modern in spirit and vision.

This period of the beginning of Constable's maturity which – as we have seen – occurred in 1810-11, was one of great creativity, when paintings and sketches of equal intensity of feeling were produced. But at about this time, his work began to change and develop in a different direction: in a certain sense it became more thought-out, planned with greater meditation.

The difference which began to appear between the sketches and the finished canvases reveals in the latter an indulgence in the arcadian tradition of eighteenth-century *vedute*, a return to a serene style of rugged foregrounds, leafy branches and distant skies lit up by flashes of light. It was in the sketches that the true artist was revealed, noting rapidly the detailed manifestations of nature with a lively spontaneity which was already completely impressionistic. *Dedham Vale (pl. 65)* on the one hand, and *A View on the Stour* (ill. in black and white on p. 19) on the other, show this difference very clearly.

Probably the reason was a practical one: Constable noted his immediate emotions in small paintings, that is, in the form of studies, and he painted larger works on the basis of his first impressions. ' I am determined to finish a small picture on the spot, for every large one I intend to paint ', he wrote to Dunthorne in 1814; this is a process which, if it slightly diminishes the value of the sketches by considering them merely as a practical step towards the important canvases, yet was a procedure commonly adopted by other great painters, either of the same time as Constable or later. One need think only of Corot and Delacroix, who summarily jotted down their first impression and then worked from their sketch in the tranquillity of their studios.

It was not until 1813 that Constable was able to sell his first landscapes, and then disapproval was expressed not only by official critics, but also by his friends, who found that his painting was sombre and gloomy, taking no heed of the examples of the masters of the past. In 1812 his great friend John Fisher pointed out to Constable that his works were not attracting sufficient attention. These criticisms certainly had their effect upon the development of Constable's art, so that, as Arcangeli has observed, it became directed to 'a more facile romanticism, an unconfessed desire to astonish the viewer'.

Now Constable began to neglect the more natural and ordinary features of landscape and to concentrate on the exceptional and spectacular. In 1812 he painted *Landscape with a Double Rainbow*, a work typical of this new development. But other works of the same period also show similar characteristics, for example *Hampstead Heath* (*pl. 29*), where landscape gives way to 'genre' painting (Arcangeli was to speak of an 'incipient mannerism') as Constable strove to make his paintings acceptable.

This process of striving after effect, together with a detached analysis of the elements of composition, reached its climax – as Venturi has pointed out – in *Flatford Mill on the Stour* (*pls 26-7*) of 1817, to which *Boat-Building near Flatford Mill* was a forerunner in 1815. The sources which influenced Constable at this time were Canaletto (from whom he assimilated the dry, clear colour tones, as well as a cold, analytical attention to detail) and Hobbema. Referring to Hobbema, Arcangeli sees in Constable also a movement away from the 'phenomenal' to the 'agreeable', and so defined a defect 'not of execution, but of conception', which became an intrinsic feature of Constable's new view of nature as something pleasant and acceptable to the taste of the public, which preferred a more superficial and well-tried style of painting.

This severe judgment of Arcangeli does not have to be accepted in its entirety, however, for it should not be forgotten – as he himself has not – that during the same period Constable was painting authentic masterpieces, such as his *Study of an Elm*, of 1815, *Wheatfield with Figures*, 1816,

A View on the Stour: Dedham Church in the distance, 1830-6 (see p. 38)

and *Weymouth Bay*, 1816 *(pl. 24)*, about which Leslie stated without hesitation that Constable's art had never attained such perfection as at this period of his life. These works undoubtedly provided the most immediate and direct transition to the painting of Corot, whose theories Constable was the first to put into practice, and the works of the impressionists whom, as Cogniat has said, he anticipated

by at least half a century. And Corot, it must not be forgotten, always made a clear distinction between studies and Salon pictures, not only in a ' political ' sense, but also from the aesthetic point of view.

In 1819 Constable painted the famous canvas *The White Horse*, an extremely compelling painting whose sensitive atmospheric effect owes much to Ruysdael, and also to Dughet and Claude. There followed a five-year period until 1824 which was the most creative in Constable's career, when the following works were produced: *Stratford Mill*, 1820, *Dedham Mill*, 1821, *The Haywain*, 1821, *View over the Stour*, 1822, *Salisbury Cathedral from the Bishop's Grounds*, 1823 *(pls 48-9)*, etc.

Referring to this group of works, C. J. Holmes has spoken of a compromise between art and nature; and Arcangeli too adopts this interpretation, sighing for the naturalism which had now been lost, at least in the official works. Venturi states, however, that masterpieces were born when Constable's realism and romanticism coincided: ' There is a short period in Constable's life, from 1820 to about 1825, when they did coincide in a particularly spontaneous way; this was the happiest period of his art. Before 1820 the realist usually predominated, after 1825 the romantic came to the forefront. '

In the period of intense creativity between 1819 and 1825, Constable fully explored the limitless possibilities of his art. The English countryside was unfolded to the view in its most enchanting aspects: old mills, lonely cottages, trees, clear streams flowing through well-watered foliage, dew-drenched fields, boys at the locks or on boats. He wrote in a letter in 1821, ' The sound of water, escaping from mill-dams, etc., willows, old rotted planks, slimy posts and brickwork, I love such things... I associate " my careless boyhood " with all that lies on the banks of the Stour. Those scenes made me a painter, and I am grateful. '

In this unforgettable Suffolk landscape, there is the magic of the artist's favourite seasons: the silent autumns still imbued with the warmth of summer, or the many-faceted springs when the browns come to life on contact with water and the cold greens stand out clearly against skies striped with blue. The sun is reflected by the wind-blown leaves,

the trees rise against cloud-covered skies presaging rain. Fuseli once remarked that Constable's landscapes made him ' call for my great coat and umbrella '.

Constable made detailed notes on the seasons, recording for example that the decomposition of vegetation creates a damp which makes shadows blue and gives the landscape a cold tone. These annotations are not merely literary passages, but are matched by the way these features are treated in the paintings. Constable's technique is arid, dry and concise, sometimes excited, as he follows the progression of the seasons as they change from day to day, from hour to hour and from second to second.

Constable's speed of execution is not therefore to be considered merely an exhibition of technical prowess or ' bravura ' (such as the concept of the ' picturesque ' would entail), but as a methodical and obstinate determination to match in rapidity of execution the sudden changes of day and hour in their most fleeting and variable moods. Leslie observed that a series of sky studies bore the following annotation: ' 5th of September, 1822. Ten o'clock, morning; looking south-east; brisk wind at west. Very bright and fresh, grey clouds running fast over a yellow bed, about half-way in the sky. ' This is the precision of a meteorologist as well as a painter, and takes account of the scientific classification of clouds made by Luke Howard in 1803.

His rapid execution was therefore much closer to Manet than to Turner, and the more it was based on a precarious equilibrium, the deeper it penetrated into the study of natural truths.

Thick brush-strokes alternate with areas treated in the same way as watercolours. Colours vary from dry, thinly-applied tones to brilliant, heavy-textured patches, from an all-enveloping silvery glow to a sudden frenzy of wild emotion. Light is the unifying factor, bringing animation and vigour (G. Reynolds).

As we can see, Constable's original vocation to be a ' natural painter ', planned for himself as early as 1802, did not change fundamentally, although it took varying forms at different stages in his career. Of course, in the works of his mature period nature had become more manageable, less

rigid and intractable than it had been at the time of his early works, and perhaps just because of this greater facility Constable's painting sometimes came very close to a manneristic style.

The romantic side of his nature became more predominant after 1823. There were two motivations for the direction his art now began to take: on the one hand, it was the time of the literary beginnings of the romantic movement (soon to permeate the whole of European culture), while on the other hand, there was also a new attitude towards landscape. The pleasant hills of the Stour were not to be the vehicle for these new emotions, but the dark ochres of Hampstead Heath, a tormented landscape overhung by a sky heavy with clouds.

Hampstead Heath was not a new subject for Constable: what was new was his way of seeing it. In a small, delightful painting of 1821, *Buildings on Rising Ground near Hampstead (pl. 46)*, the natural painter, the tireless searcher for atmospheric effects, predominates: it is a view of a pleasant, green hill, surrounded by transparent water courses whose gentle murmur is preserved in the painting, the brown foreground blocked in under a blue sky tinged with rose, lilac and grey, and the whole enveloped in light breezes which impart a luminous atmosphere of exquisite delicacy. In the romantic vision, the emphasis is on dramatic effect, brought about by a succession of planes, by the violent movements of groups of figures, and the technique of contrasting heavy impasto with broad surfaces of thin atmospheric tones.

Meteorological interest now became centred on the phenomenal; the ordinary aspects of nature no longer held the fascination Constable had always found in them and he turned more and more to the extreme manifestations of nature. Hampstead was again the subject of a canvas in 1833 (Victoria and Albert Museum) and this time it was seen as in a dazzling vision, as though the romantic view of nature had now reached its paroxysm. However, this romantic view did not become rhetorical (with the exception of certain views, such as *Hadleigh Castle*, 1829, or *The Cenotaph (pl. 87)*, 1836, where the romantic taste for ruins, for

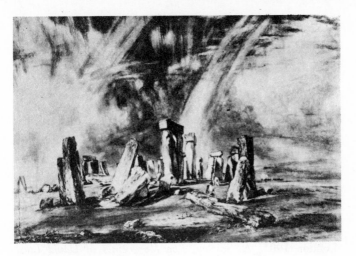

Stonehenge, 1835 *(see p. 39)*

historical and monumental themes, could be seen clearly
for the vacuous and superficial thing it was) but was very
human, even in the more facile theatrical paintings, like
the famous *Stonehenge* of 1835.

However, the 'natural painter' still flourished: in certain
sketches of Hampstead, for example *Evening in Hampstead*,
1823, in *The Country Road*, 1826 (so tremulous with its
trees and foliage that it foreshadows Sisley), and the famous
Dedham Mill (painted between 1826 and 1828). The scope
of Constable's research had broadened, however; the tech-
nique had become much more complex and cultural sources
now stretched as far as Rubens; storms were a recurring
theme, as if Constable's own unhappy mind found its par-
allel in the spectacle of nature torn asunder.

After 1830 Constable was mainly concerned to bring his
paintings to a greater degree of 'finish': his work seemed
to be a long meditation on the pictorial themes of his
lifetime. Those were the themes which were essential fea-
tures in the development of European art and had enabled
Constable – 'the first modern painter' – to anticipate by
half a century the discovery of impressionism.

23

Constable and the Critics

Memoirs of the Life of John Constable, by the American artist C. R. Leslie, is without doubt the basic work on the life and art of Constable, of whom Leslie was a close friend for more than twenty years.

Among the vast English bibliography, the works which have been most frequently consulted are: C. J. Holmes, *Constable and his Influence on Landscape Painting*, London 1902; Earl Plymouth, *John Constable, R. A.*, London 1903; Lord Windsor, *John Constable, R. A.*, London 1903; Sir J. D. Linton, *Constable's Sketches in Oil and Water Colours*, London 1905; A. Shirley, *The Mezzotints of David Lucas after John Constable*, Oxford 1930; P. Leslie, *The Letters of John Constable, R. A. to C. R. Leslie, R. A.*, London 1931; H. I. Kay, *The Haywain*, BM 1933; S. J. Key, *John Constable, His Life and Work*, London 1948; A. Shirley, *The Rainbow: A Portrait of John Constable*, London 1949; K. Badt, *John Constable's Clouds*, London 1950; R. B. Beckett, *John Constable and the Fishers*, London 1952 (a complete critical edition of the correspondence between Constable and Fisher); J. Mayne, *Constable Sketches*, London 1953; G. Reynolds, *Catalogue of the Constable Collection, Victoria and Albert Museum*, London 1959; R. B. Beckett, ' Constable and his Critics ', *Apollo*, LXXVII, 1962; C. Moss, ' Painting in the Blood ', *Studio*, 165, 1963; R. B. Beckett, ' Constable at Epsom ', *Apollo*, LXXXI, 1965.
Useful information is provided by the article ' Constable ' (by G. Reynolds) in *Encyclopedia of World Art*, Vol. III, London 1960.
Additional critical material is contained in the collection of lectures given by G. C. Argan in Rome University (*cf.* G. C. Argan, *La Pittura dell'Illuminismo in Inghilterra da Reynolds a Constable*, edited by M. Fagiolo, Rome 1965), and the essay by the same author in *Scritti di Storia dell'Arte in onore di Mario Salmi*, Vol. III, Rome 1963.

Notes on the Plates

Self-portrait, c. 1800 (*ill. in black and white on p. 5*). Pencil and watercolour on paper, 25.4 × 20.3 cm. London, National Portrait Gallery. This self-portrait follows the neo-classical tradition: there is not the slightest trace of the ease and freedom of other portrait sketches, of which there are examples, such as we find in the *Portrait of Mrs Andrew* (see *pl. 28*). Probably Constable's main interest here was to reproduce his own features accurately, and possibly with a certain degree of vanity. Note a certain similarity between this work and the youthful self-portrait of Turner.

A Ruined Cottage at Capel, Suffolk, 1796 (*ill. in black and white on p. 9*). Pen on paper, 18 × 30 cm. London, Victoria and Albert Museum. This is one of a group of thirteen drawings produced in 1796, soon after Constable came to know J. T. Smith. Most of these drawings are of ' picturesque ' cottages and – as G. Reynolds has rightly observed – they show the obvious influence of Smith. Constable drew unceasingly and often used his rapid sketches from nature as the basis for large compositions executed later in his studio. This process, which reduced the sketch to the value of an instrument, was used to a large extent, mainly in the mature period of his activity. This method – adopted also by Corot – has been, and still is, condemned by a certain school of critics, who see in this polishing of the sketch the loss of the immediate and genuine emotion which originally inspired the artist.

1 Dedham Vale, September 1802. Oil on canvas, 43.5 × 34.4 cm. London, Victoria and Albert Museum. This is the first work which fully reflects Constable's wish to be a ' natural painter ' (Reynolds). Shirley has noted the similarity between the composition of this painting and that of Claude's *Hagar and the Angel* (National Gallery, London). Constable was to return to the same subject many years later in the famous *Dedham Vale* or 1828 (see *pl. 65*).

2 Head of a Girl, 1806-9. Oil on canvas, 31.2 × 30.5 cm. London, Victoria and Albert Museum. According to Beckett, this could be a portrait of the artist's younger sister Mary. Constable has not left us many examples of his portrait painting; when the human figure does appear, it is never as a protagonist, but as an almost marginal element in the landscape. Here, however, we have a portrait vibrant with life and expressiveness. It anticipates some of the impressionist portraits and in some ways is close to Renoir, especially in the attitude of the girl, not at all like a ' posed ' portrait, but captured at the instantaneous and fugitive moment which reveals the innermost soul, so that the portrait ceases to be generalized and is given its specific quality.

3 Shipping in the Orwell, near Ipswich, 1806-9. Oil on cardboard, 20.2×23.5 cm. London, Victoria and Albert Museum. This work shows clearly the strength of Constable's desire, by about the year 1806, to be free from the influence of any previous form of art. Here the diligence of the draughtsman has yielded to the freedom of the lyric poet. The form of the work is already impressionist, in that there is an immediate correspondence between the world of vision and the world of sensation. This work (there is a landscape with five cows on the back) is the first sketch for the mezzotint published in the 1838 edition by Lucas under the title *View over the Orwell, near Ipswich.*

4 Flatford Mill from a Lock on the Stour, c. 1811. Oil on canvas, 24.8×29.8 cm. London, Victoria and Albert Museum. Flatford Mill was bought by the artist's father and portrayed by Constable on Page 10 of the 1813 album, now in the Victoria and Albert Museum (n° 317, 1888), in the canvas *Flatford Mill on the Stour*, Tate Gallery (see *pls 26-7*), on the paper laid on canvas *Boats on the Stour*, in the gouache *Men Loading a Boat on the Stour*, and the drawing *Flatford Mill*, all in the Victoria and Albert Museum.

5 A Village Fair (probably at East Bergholt), 1811. Oil on canvas, 17.2×35.5 cm. London, Victoria and Albert Museum.

6-7 A Cart on a Country Road, 1811. Oil on paper laid on canvas. London, Victoria and Albert Museum. In a small plate set in the frame is the date, 17 May 1811, followed by the monogram L.B.C. (Lionel Bicknell Constable, the artist's youngest son). There are close stylistic similarities between this work and *Flatford Mill from a Lock on the Stour.*

8-9 Morning in Dedham Vale, 1811. Oil on canvas, 79×129.5 cm. Peterborough, Sir Richard Proby Collection. Exhibited in Rome 1966. In the catalogue to the exhibition, G. Carandente points out the features of the Stour Valley landscape seen from the hills of East Bergholt: ' on the background there can be seen (from left to right) the villages of Bedham, Langham and Stratford'. This painting was first exhibited at the Royal Academy in 1811.

10 Sketch for Glebe Farm, 1810-5. Oil on canvas, 19.7×28 cm. London, Victoria and Albert Museum. This sketch is treated in an impressionistic manner which is unusual for the period. This is probably a reflection of Constable's conception of the sketch at that time as ' something which kept alive for him the emotion of a chosen landscape' (Arcangeli).

11 View of Dedham, 1810-5. Oil on paper laid on canvas, 23×30 cm. London, Victoria and Albert Museum. This is a characteristic example of Constable's youthful manner: nature is studied calmly

and the resultant landscape is serene and spacious. Nature as it appears in this work, and the feeling it inspires, are at variance with the Dutch and classical tradition; the sense of the 'sublime' is absent, so too is the taste for the 'picturesque'. Instead, Constable depicted the simplicity and unspoilt quality of the English countryside of the Stour region, which he loved so dearly. It was this Stour landscape and the artist's youthful impressions which encouraged him in his vocation to be a 'natural painter'; in this he followed the example of the *Lyrical Ballads*, in which Wordsworth wrote of subjects connected with the humble life of the fields: 'the manners of rural life germinate from those elementary feelings; and from them the necessary character of rural occupations are more easily comprehended; and are more durable...'.

12 Willy Lott's house near Flatford Mill, 1810-5. Oil on paper, 24.1×18.1 cm. London, Victoria and Albert Museum. This is a small 'domestic' painting, where all the ingredients of Constable's art are found: the house by the pond, the running dog, large shady trees, and the mill. The paint is applied in thick patches and the emphasis on chiaroscuro shows clearly Constable's summary method of jotting down the salient elements in the composition. This study is probably for the left portion of *The Haywain*.

13-14 Spring, East Bergholt Common, c. 1814. Oil on millboard laid on panel, 19×36.2 cm. London, Victoria and Albert Museum. Known also under the title *Spring, Ploughing a Flat Field by a Windmill*. From this oil sketch David Lucas produced a mezzotint under the same title, published in the first volume of *English Landscape* (June 1830).

15 Flowers in a Glass Vase, c. 1814. Oil on millboard laid on panel, 50.5×33 cm. London, Victoria and Albert Museum. Constable rarely painted still-lifes: this oil, with the following, is one of the few examples we have (see also *pl. 35*). Although the subject-matter of landscapes enabled Constable to utilize a technique of applying colour in broad masses, this delightful sketch provides a proof of his versatility. It is a delicate little sketch, with clear, transparent tones and half-tones, and is completely free from the influence of the great Dutch still-life tradition.

16 Study of Flowers, 26 July 1814. Oil, millboard laid on panel. 49.5×33 cm. London, Victoria and Albert Museum. The last two figures of the date are practically illegible, owing to the painting's deterioration. In the 1888 catalogue it was dated 1804. A more likely date, from the stylistic point of view, is that given by Holmes (1814), with which Reynolds concurs.

17 Study of a Cart with Two Horses, 24 October 1814. Oil on paper, 15.9×26.4 cm. London, Victoria and Albert Museum. In 1814 Constable wrote to Dunthorne that he intended to finish small

sketches ' on the spot '. This work could be a sketch for more finished compositions to be worked at later in his studio. In 1821 Constable produced some drawings on the same subject.

18 Study of Two Ploughs, 2 November 1814. Oil on paper, 17.2×26 cm. London, Victoria and Albert Museum. This forms part of a group of notes and sketches relating to agricultural implements. It is highly probable that this study was used for the plough in the foreground of the painting *Stoke-by-Nayland* (after 1830), now in the collection of Mr and Mrs W. W. Kimball at the Art Institute of Chicago. Constable was an attentive observer, not only of the countryside, but also of the means utilized by man to cultivate it and benefit from its riches: ' Although this may seem paradoxical, it is no exaggeration to call Constable a painter of the industrial landscape ' (Reynolds).

19 Study of a Cart and Horses with a Carter and Dog, 1814. Oil on paper, 16.5×23.8 cm. London, Victoria and Albert Museum. This was identified by Beckett in 1956 as a sketch for the cart and horses at the gravel pit depicted in the canvas *The Valley of the Stour and Dedham Village*, now in the Boston Museum of Fine Arts.

20-1 The Mill Over the Stream. Oil on canvas, 71×91.5 cm. Ipswich Museum. The subject of this painting – exhibited for the first time in 1814 at the Royal Academy – is the house of Willy Lott (see *pl. 12*), an eccentric individual whom Constable knew well. In the Tate Gallery collection there is a sketch for this painting, from which Lucas took his mezzotint *The Mill Stream*. The painting was exhibited in Rome in 1966.

22-3 Boat-Building Near Flatford Mill, 1815. Oil on canvas, 50.8×61.6 cm. (transferred to thicker canvas in 1893). London, Victoria and Albert Museum. A pencil sketch for this canvas is to be found in the album which Constable used, between July and October 1814, for his notes on Essex and Suffolk. This is one of Constable's basic works, first exhibited in 1815. Leslie praised it highly for the way Constable had succeeded in reproducing the atmosphere on his canvas. The picture was painted in the open air in the summer and autumn of 1814 (but undoubtedly later revised in the artist's studio). The composition followed fairly closely the tradition of the classical and the Dutch landscape. In the minute treatment of the detail in the foreground some critics have seen – perhaps not without reason – a certain detachment from the subjects Constable was painting and, as in the case of the more famous, but later, *Flatford Mill* of 1817 (see *pls. 26-7*), a considerable lack of uniformity in the styles of the foreground, the sides and the background.

24 Weymouth Bay, 1816. Oil on canvas, 20.3×24.7 cm. London, Victoria and Albert Museum. Probably painted in the autumn of

1816, during Constable's honeymoon in Dorset. However, in technique and composition this work differs considerably from other paintings of the same period. No emphasis is given to detail; instead, the treatment is impressionistic and the effect of depth is stressed: against the background, the mountains merge with the sea and sky. The swirling movements of the sky recall Turner, though without equalling his refined elegance. As in the National Gallery versions, it has certain features which are characteristic of Lucas's engravings.

25 A Cottage in a Cornfield, c. 1817. Oil on canvas, 62 × 51.5 cm. London, Victoria and Albert Museum. Constable exhibited a painting bearing this title at the Royal Academy in 1833 and at the British Institution in 1834. The measurements given in the catalogue to the 1834 exhibition correspond roughly to those of this painting. The general conception of the work and, especially, stylistic reasons would, however, make it seem more likely that it was executed about the year 1817.

26-7 Flatford Mill on the Stour, 1817. Oil on canvas, 102 × 127 cm. London, Tate Gallery. In this work, exhibited at the Royal Academy in 1817, Constable has painted the mill buildings over the lock. Constable was inspired in other works also by this navigable part of the River Stour: *The White Horse, The Leaping Horse* (*pls 58-9*), *The Haywain* (*pls. 39-40*), *The Lock*, and others. The landscape induced in him a feeling of solemn reverence. The great naturalistic movement in landscape painting, for which all Europe was waiting, had begun already in this work, which was conceived in the same spirit as motivated Wordsworth's poetry. Nevertheless, as Venturi has noted, there are many shortcomings in this painting, purely from the pictorial point of view, especially an over-emphasis on technical skill:

' The natural scene is realistically represented in its deep perspective, its proportions and its precise treatment of detail. But the style is not uniform: the forms seem to be seen in themselves, the colour and light in themselves too, so that the result becomes nature in chaos, not a pictorial style. The figures are drawn as if contrast of light and shade did not exist. The painting is smooth, in order to outline the forms clearly, ignoring contrasts of light and shade which demand a rough surface. It is an impeccable example of the work of a follower of Hobbema, but the personality and poetic imagination of the artist are lacking. Solidity, skill, conscientiousness, are here; what is lacking is impulse, freedom, creativeness. '

28 Portrait of Mrs Andrew, 1818. Oil on canvas, 63 × 76 cm. London, Tate Gallery. With its companion, *Portrait of Mr Andrew* (Addiscombe College), this is one of Constable's last portrait commissions. The technique and use of colour served as an example to the French impressionists, Monet first and foremost. The style of this portrait differs completely from that of the fashionable English portrait painters of the time, from Lawrence to Gainsborough.

29 Hampstead Heath, 1819. Oil on canvas, 61.5×79.5 cm. London, Lord Inchcape Collection. Exhibited in Rome in 1966. In the catalogue to the Rome exhibition, Carandente wrote that in the summer of 1819 Constable had set up a home in Hampstead, at the time a village on a hill north of London, in the hope that the healthy air would be beneficial to his wife's health. He returned to Hampstead regularly in the summer, and produced many paintings there. The sketch now in the Victoria and Albert Museum was certainly painted during his first stay, in 1819. This canvas must have been painted at about the same time. However, several versions of this subject exist (including one in the Tate Gallery), the best known of which is the one painted in 1828, now in the Victoria and Albert Museum (see *pls 62-3*).

30-1 The Opening of Waterloo Bridge, c. 1819. Oil on canvas, 29.2×48.3 cm. London, Victoria and Albert Museum. Waterloo Bridge was a subject frequently painted by Constable, from the time when he was present at the opening ceremony on 18 June 1817. In addition to numerous sketches, it was also the subject of an important painting.

32-3 Dedham Lock and Mill, 1820. Oil on canvas, 53.7×76.2 cm. London, Victoria and Albert Museum. Several versions of this subject are in existence, with slight variations on the painting exhibited in 1820 at the Royal Academy: the painting in the Currier Gallery of Art, Manchester, New Hampshire (dated 1820 by Leslie), the study in the Tate Gallery and the small oil sketch in the Victoria and Albert Museum. The mill, entirely reconstructed, was the property of Golding Constable. This is a brilliant example of Constable's view painting at its complete maturity. The salient features of the landscape are treated in sharp relief – even those not strictly necessary – yet they merge perfectly under a serene, perfect light. This painting contains, in synthesis, all the elements of landscape which Constable loved best: the river, the boats, the soaked logs, the river vegetation, the sun shining through the foliage of the tall trees, the scenes of rural life and, above all, Dedham Mill. The cultural origins of this work are apparent in the traditional composition, in the use of chiaroscuro, in the way the landscape fades into the distance, after the Dutch manner, and in the complex, laboured palette. The compact tree mass in the foreground is blocked in against a sky filled with movement, reflected in the calm and transparent waters over which plays a pallid sun, as we find in Ruysdael. It was works such as this (together with *The White Horse, Salisbury Cathedral from the Bishop's Grounds, Stratford Mill, The Lock, The Haywain*) which were meant to ensure Constable's place in official art history, and although he observed the exigencies of art, he undoubtedly also took heed of what might be expected by the public and critics.

34 Salisbury Cathedral, 1820? Oil on canvas, 25.1×30.2 cm. London, Victoria and Albert Museum. Constable visited Salisbury for

the first time in the autumn of 1811; the cathedral immediately made a great impression on him and became the subject for a series of drawings and paintings. Compared with the famous version of 1823, *Salisbury Cathedral from the Bishop's Grounds* (*pls* 48-9), this study has the virtue of great freshness and immediacy, with a lesser emphasis on technique. It has a greater degree of spontaneity and was painted from direct observation of the English countryside and the changing seasons. This work must have been executed in 1820, when Constable was staying with Archdeacon John Fisher, the nephew and chaplain of the Bishop. Constable is not here greatly concerned with 'composing' a painting, or with the grand manner of the French and Dutch tradition; what he finds of especial significance is the luminosity, the patches of dense greens, the trees and meadows, the golden stone of the barely sketched-in cathedral, its spire standing out against a sky flecked with clouds, which are painted in areas of colour broken up by vast spaces.

35 Study of Foliage, 1820-30. Oil on paper, 15.2×24.2 cm. London, Victoria and Albert Museum. Holmes dates this study about 1826. Reynolds observes that it has much in common with the early studies for the great river and canal compositions, but cannot be considered an actual study for one of these compositions. There are, for example – Reynolds goes on to say – affinities with *The Leaping Horse* (1825). For this reason, as well as on stylistic grounds, the painting is datable between 1820 and 1830.

36 Study of Trees, c. 1821. Oil on paper, 24.8×29.2 cm. London, Victoria and Albert Museum. Exhibited in Rome 1966. Holmes dates this painting about 1830, but Reynolds places it some years earlier, in 1821. He states that although there are many similarities between this sketch and the paintings of Constable's final manner, it was more likely to have been painted at a time when he was engaged in a systematic study of skies and trees. The loose brush-strokes in the treatment of the foliage may be compared with the technique of certain other paintings produced about 1821.

37-8 Branch Hill Pond, Hampstead, 1820-21. Oil on canvas, 44.5×61 cm. Bury, Civic Library and Art Gallery. Exhibited in Rome 1966. The site of this painting is the same as in *pl. 29*, only the viewpoint has changed. It must have been painted about 1820, and in any case not later than 1821.

39-40 Study for The Haywain, c. 1821. Oil on canvas, 137×188 cm. London, Victoria and Albert Museum. This study, painted about 1821, is a preliminary sketch for the work exhibited by Constable at the Royal Academy and which is now in the National Gallery, London. At the 1824 Paris Salon, where he received a gold medal, *The Haywain* made a profound impression upon the young artists who banded together to form the Barbizon School; Delacroix, too, greatly admired it.

41 Study of the Trunk of an Elm Tree, c. 1821. Oil on paper, 30.6×24.8 cm. London, Victoria and Albert Museum. Constable loved trees; Chamot recalls that in a lecture Constable once spoke about a tree which he had drawn and had since died, and was ' heartbroken ' because a notice-board had been affixed to it. The foreshortened effect is interesting. It is a very detailed work, in which nature is so meticulously studied that the general conception of the landscape becomes lost from sight. Here too, as in many other of his sketches, Constable anticipated the pitiless, almost photographic eye of the realistic school which followed him.

42 Trees at Hampstead, the Path to the Church, September 1821. Oil on canvas, 91.5×72.5 cm. London, Victoria and Albert Museum. Exhibited in Rome 1966. This painting is unfinished in some details, yet the unrhetorical mastery with which Constable has depicted this group of trees reflects the love he bore for the various aspects of nature.

43-4 Hampstead: Pond, c. 1821-2. Oil on canvas, 24.5×39.5 cm. London, Victoria and Albert Museum. Exhibited in Rome 1966. Dated by Holmes about the year 1827. Reynolds, however, notes considerable similarities between this painting and *Summit from Hampstead Heath - Evening* (Manchester City Art Gallery), dated 1821, as well as *View of Hampstead - Evening* and *Hampstead, Stormy Sunset* (Victoria and Albert Museum), which are both dated 1822.

45 Study of Sky and Trees, 21 September (1821). Oil on paper, 24.8×29.8 cm. London, Victoria and Albert Museum. Exhibited in Rome 1966. This is one of the numerous studies of clouds and skies painted between 1816 and 1822. In 1822 Constable wrote to his friend Fisher: ' I have done a good deal of skying... I have often been advised to consider my sky as *a white sheet thrown behind the objects*... [but] it must and always shall with me make an effectual part of the composition... the keynote, the standard of scale, and the chief organ of sentiment. '

This series of studies, all scrupulously dated, was of an exceptional meteorological exactitude, as if the artist had wished to register every minute detail of the cloud formations, every variation in the movement of the winds. Constable was not only determined to study nature with a vigilant eye, ready to record the slightest changes of atmosphere, but also found it necessary to complete his observations by means of written notes, as if painting alone were inadequate to do full justice to nature. It is obvious, therefore, that he used the sketches as first impressions and working models to be transferred later to the large canvases which he painted in his studio.

46 Buildings on Rising Ground Near Hampstead, 13 October 1821. Oil on paper, 24.8×29.8 cm. London, Victoria and Albert museum. The calm, sunlit landscape of Hampstead Heath played a

very important part in Constable's painting. Besides the obvious influence over his choice of subject-matter, it also favoured his growing indulgence in the sentimental and rhetorical features of romantic art. This development, which began about 1823, had not yet made its mark on this small masterpiece. The execution is so fresh and penetrating that it would seem to have been affected by the painting of Van der Neer, and to owe a certain debt to Turner.

47 View of Lower Terrace, Hampstead. Oil on canvas, 24.8×35.2 cm. London, Victoria and Albert Museum. This painting was catalogued in 1888 under the title *Red House in Hill Road, Morning.* Holmes dates it about 1815 and describes it as *Houses and Trees in Hampstead.* In the Royal Academy catalogue, among works exhibited by Constable in 1822, was one entitled *View from Terrace, Hampstead.* This title was corrected by Leslie to *View of Terrace, Hampstead.* According to Reynolds, if Leslie's correction is to be accepted, this canvas could well be the one which was shown in 1822 or perhaps a study for it. However, it seems quite likely that it was painted at the time when Constable was living in Hampstead, that is, in 1821 or 1822.

48-9 Salisbury Cathedral from the Bishop's Grounds, 1823. Oil on canvas, 87.6×111.8 cm. London, Victoria and Albert Museum. This version of Salisbury Cathedral seen from the Bishop's grounds is one of many, and is perhaps the best known and most important of them all. The Bishop of Salisbury, who came from Suffolk where he had been the vicar of Langham, invited Constable to stay with him. As previously related, Constable went to Salisbury for the first time in 1811 and during that visit he formed a close friendship with the bishop's nephew and chaplain, John Fisher; this friendship was to become of fundamental importance to the development of his art, owing to the intelligence and broad culture of Archdeacon Fisher. As far as we can gather, it would seem that the Bishop did not care for this painting, mainly because of the violent contrast between the shadows over the foreground and the sharp light enveloping the cathedral; in fact, the painting was rejected. When we compare this version with the large sketch in which the spires are almost hidden by trees (National Gallery, London) or, especially, the sketch done for this painting (Ramsden Hall, T. W. Bacon Collection) – described by Venturi as ' one of the highest achievements ever recorded in the history of art... We can find no similar high achievement until we come to Cézanne ' – we find in it an excessive degree of sophistication which detracts from the poetical quality. Excessive, too, is the emphasis on detail, especially in the foliage and punctilious noting of architectonic features, which reduces the painting to ' an inventory of the triforia, the spires, the roof ' (Venturi).

50 Windmill Among Houses, with a Rainbow, c. 1824. Oil on paper laid on canvas, 21×30.4 cm. London, Victoria and Albert

Museum. Reynolds believes this was painted near Brighton, and he dates the sketch to about 1824. In fact, it is practically the same landscape as in *Mill near Brighton* (dated 3 August 1824). Holmes is in agreement over this dating, for reasons of style and technique.

51 Brighton Beach, 29 July 1824. Oil on paper, 16.5×30.4 cm. London, Victoria and Albert Museum. This is one of the most peaceful views of the Brighton period. The left foreground, painted in a photographic manner, recalls the past experiences of *The Haywain* and *Boat-Building near Flatford Mill*, based on an analytical and detached study of detail. The remainder of the work is treated in a rapid, summary manner. The small figures lending animation to the scene recall the graceful figures of Guardi. But here the treatment is more impressionistic, anticipating the varicoloured crowds of the impressionists' boulevards. In a letter to Fisher dated 29 May, Constable complained:
' Brighton is the receptacle of the fashion and off-scouring of London,... footmen, children, nursery-maids, dogs, boys, fishermen, and Preventive service men with hangers and pistols; rotten fish and those hideous amphibious animals, the old bathing-women...'.
This sketch is remarkable for the transparency of its colours, and its atmosphere which seems to have been bathed by a recent fall of rain. There is a note in the artist's hand: ' Very fine evening '.

52 Beach Scene, with Fishing Boats, c. 1824. Oil on paper laid on canvas, 31.7×49.5 cm. London, Victoria and Albert Museum. Constable eliminates non-essential detail and concentrates on the representation of the typical elements of coastal scenery: the sea, beach and sky. The composition is intelligently balanced and a thick application of paint gives prominence to the realistic touches of surf. Reynolds remarks, ' There are numerous *pentimenti* altering the position of the boats on the sky-line '.

53 Brighton Beach, 19 July 1824. Oil on paper, 13.6×30.2 cm. London, Victoria and Albert Museum. On the back is this note in Constable's hand: ' Beach Brighton. July 19. Noon, 1824. My dear Minna's birthday ' (Maria Louise, Constable's wife). In the letter about Brighton already quoted, Constable wrote, ' In short, there is nothing here for a painter... The fishing-boats here are are not so picturesque as the Hastings boats... But these subjects are so hackneyed in the Exhibition, and are indeed so little capable of the beautiful sentiment that belongs to landscape, that they have done a great deal of harm. They form a class of art much easier than landscape, and have, in consequence, almost supplanted it. '.

54-5 Brighton Beach with Colliers, 19 July 1824. Oil on paper, 14.9×24.8 cm. London, Victoria and Albert Museum. This is one of the marine studies executed by Constable while he was living in Brighton for the sake of his wife's health. Like the other sketches, it is a precocious anticipation of the paintings of the impressionists.

56-7 Study for the Leaping Horse, c. 1825. Oil on canvas, 129.4×188 cm. London, Victoria and Albert Museum. Painted about the year 1825, the definitive work was exhibited at the Royal Academy in the same year. It forms part of that series of large paintings of river scenes which Constable executed between 1819 and 1825. A sense of drama is created by the stormy sky, the horse preparing to leap, the squally trees and the water which pervades everything. This is a type of English landscape which differs greatly from those Constable generally preferred.

58-9 The Leaping Horse, 1825. Oil on canvas, 140×185.5 cm. London, Royal Academy of Arts. Exhibited in Rome 1966. In the catalogue to the Rome exhibition, Carandente recalls that when the artist sent this painting to the Academy for the 1825 exhibition, he wrote: ' It is a lovely subject, of the canal kind, lively – & soothing – calm and exhilarating, fresh – & blowing, but it should have been on my easil a few weeks longer. '
This painting varies slightly from the study now in the Victoria and Albert Museum (for example, the willow to the right behind the leaping horse is here moved to the centre of the composition). ' The pictorial matter is of an amazing intensity, as are the richness of the colour variations, the subtlety of formal relationships, the sparkling quality of the brush-strokes ' (Carandente).

60 Marine Study with Rain Clouds, c. 1824-8. Oil on paper, 22.2×30.8 cm. London, Royal Academy of Arts. The writer is of the same opinion as Reynolds, who described this study as one of the most important works to be executed by Constable during his visits to Brighton in the years 1824-8. In this painting – which clearly recalls the great Turner – light is the material of colour.

61 The Cornfield, 1826. Oil on canvas, 142×122 cm. London, National Gallery. Exhibited in 1826 at the Royal Academy (together with *Parham Mill*) and in 1827 at the Paris Salon. After Constable's death, it was presented to the National Gallery by a group of his admirers. The painting is of a path running across fields to join East Bergholt and Dedham, a path frequently crossed by Constable during his walks. It is one of his best-known works, scrupulously attentive to minute detail and technique. The figure of the little shepherd quenching his thirst harks back to the genre painting of the eighteenth century. In the receding background, made transparent by the light and air, Constable has undoubtedly taken account of the example of the classics, especially Claude.

62-3 Hampstead Heath. Oil on canvas, 59.6×77.6 cm. London, Victoria and Albert Museum. This is one of the many variants of the subject of Hampstead Heath. According to Beckett, it was first exhibited at the Royal Academy in 1828. Compared with previous views of Hampstead, this is a more atmospheric painting of a city suburb, never before painted in this way. The most immediate source

is Ruysdael, but in his search for chiaroscuro effects Constable seems to go right back to Rembrandt. In this connection, Constable declared that, in his opinion, Rembrandt's use of chiaroscuro is a decidedly cunning device, the aim of his art and the private language he used in order to express feeling. This painting of Hampstead also reflects a romantic type of sentiment in the oblique rays of the sun, the changing, cloud-darkened sky, and the groups of figures placed here and there about the landscape.

64 Coast Scene at Brighton, 1828? Oil on paper, 20×24.8 cm. London, Victoria and Albert Museum. If Holmes's dating is justifiable (22 May 1824), this work must have been painted while Constable was living in Brighton. If so, the subject-matter of the landscape would have been influenced by the scenery of that part of the country: the fresh greens and the hills of the Stour are replaced by river landscapes, beach scenes, sea paintings with brightly-coloured boats. Many works of this period have an immediacy of vision and a completely improvised transparency of colour and atmosphere. As far as the date is concerned, Reynolds's hypothesis seems the most likely, for he did not overlook the note in Constable's diary which indicates that on 22 May 1824 he was in London. Therefore, if the subject of this work is in fact Brighton, then the year must be 1828.

65 Dedham Vale, 1828. Oil on canvas, 140×122 cm. Edinburgh, National Gallery of Scotland. In the whole span of his creative activity, Constable often painted recurring themes, not only in basic subject-matter (landscape), but also in specific views. This splendid painting of 1828 developed out of the 1802 *Dedham Vale*, now in the Victoria and Albert Museum. Points of contact with the preceding great landscape tradition are to be sought mainly in Claude and the vigour of Rubens; but the work undoubtedly bears the unmistakable imprint of the painter's aesthetic hindsight. This is especially apparent in the magnificent sky, which is the real protagonist of this painting. In 1821 Constable declared on the subject of skies that ' That landscape painter who does not make his skies a very material part of his composition, neglects to avail himself of one of his greatest aids ', and added: ' It will be difficult to name a class of landscape in which the sky is not the keynote, the standard of scale, and the chief organ of sentiment... The sky is the source of light in nature, and governs everything. '
This is one of Constable's most luminous paintings.

66-7 Garden and Meadow, 1829? Oil on canvas, 20×25.1 cm. London, Victoria and Albert Museum. Holmes dates this work about 1815, but Reynolds identifies the scene as a view from the window of Archdeacon Fisher's house, in which case it would have been produced in 1829 (the year of Constable's last visit to Salisbury). With this work Constable seems to wish to show that it is not necessary to make nature match up to a conventional idea of the ' beautiful ': that to produce a work of art it is enough to study

reality in the form in which it is presented to our daily attention, and portray it in the simplest and most direct way possible. The painting is therefore a most explicit exemplification of his attitude to nature and his preference for a view of nature which is not 'pictorial', but 'natural'.

68-9 Water-Meadows Near Salisbury, 1829. Oil on canvas, 45.7×55.3 cm. London, Victoria and Albert Museum. Referring to this work, which was most probably painted at the same time as *Garden and Meadow*, Reynolds writes that this canvas – later to become famous as one of the most eloquent examples of pure naturalism – was rejected in the presence of Constable by the Council of the Royal Academy, who described it as 'a nasty green thing'.

70-1 A View at Salisbury, from the Library of Archdeacon Fisher's House, 12 July 1829. Oil on paper, 16.2×30.5 cm. London, Victoria and Albert Museum. On the back is a note by Constable: 'Fishers – library – Salisbury. Sunday July 12. 1829 4 o'clock afternoon'. This work has the characteristics of a generic type of landscape, while containing few of those spectacular and 'craftsman-like' elements in which Constable's art had begun to indulge after 1825.

72-3 Stoke-by-Nayland, Suffolk, 1829-30. Oil on paper, 24.8×33 cm. London, Victoria and Albert Museum. The year 1829 was a determining milestone in Constable's life: it was the year his wife died, and when he was elected a full member of the Royal Academy. If the 'official' crowning of his career meant economic security and unanimous recognition, the tragedy of his wife's death caused him acute crises of depression and a state of anxiety which was evident in his work – into which he threw himself feverishly. This sketch is an example of Constable's late manner. The technique shows consummate mastery: the details have been absorbed by a broad treatment of shadow and depth (*cf.* also the following painting).

74-75 A Country Road with Trees and Figures, c. 1830. Oil on canvas, 24.2×33 cm. London, Victoria and Albert Museum.

76-7 Summer Morning: Dedham from Langham, c. 1830. Oil on canvas, 21.6×30.5 cm. London, Victoria and Albert Museum. From this sketch Lucas took his mezzotint *Summer Morning*, published in September 1831 in the third volume of *English Landscape*.

78-9 A Cottage and Trees, 1830-6. Oil on paper laid on canvas, 17.8×21.9 cm. London, Victoria and Albert Museum. Holmes dates this painting about 1834, and Reynolds concurs on the basis of stylistic affinities between it and the works of Constable's last period.

80 Study of Poppies, c. 1832. Oil on paper, 60.5×48.7 cm. London, Victoria and Albert Museum. The rare examples of flower studies painted by Constable, it is generally agreed, fall into two

periods: *c.* 1814 and *c.* 1832. Reynolds justifiably places this one in the second period.

A View on the Stour: Dedham Church in the distance, 1830 (*ill. in black and white on p. 19*). Pencil and sepia gouache, 20.3×16.9 cm. London, Victoria and Albert Museum. This drawing, together with the other in the same museum, is a rare example of a return to the style of Claude and Cozens (Reynolds). Although the details of the composition are not easily distinguished, the identification of the scene as a view of Dedham has been accepted since the time the drawing was donated to the museum by Miss Isabel Constable. Constable's favourite themes, Dedham and the Stour, return in this freely painted sketch where the masses are built up and contrasted almost exclusively by means of light and dark tones. A study of the 'chiaroscuro of nature' was one of the main problems which concerned Constable as a painter and he often made this a determining factor in the evaluation of a work of art. The impressionistic treatment has blurred any incisiveness of outline; the building hidden in the trees seems to have become weightless.

81 The Grove or Admiral's House, Hampstead, 1830-6. Oil on paper laid on canvas, 24.5×29.2 cm. London, Victoria and Albert Museum. Exhibited in Rome 1966. The same building appears in the painting which was most probably exhibited in 1832 at the Royal Academy under the title *A Romantic House in Hampstead* (now in the National Gallery, London). A vertical version of the same scene, more polished in treatment and without a rainbow, is in the Berlin National Gallery. Reynolds thinks this present work could be a sketch for the Berlin painting, and would therefore have been executed about 1832.

82-3 Sketch for the Valley Farm, 1830-6. Oil on canvas, 25.4×34.9 cm. London, Victoria and Albert Museum. It was thought for a long time that this sketch was painted in 1835, as a preliminary study for the official version exhibited at the Royal Academy in that year. However, Shirley, Collins, Baker and Reynolds consider this very unlikely. It is, nevertheless, a typical example of Constable's late manner: the composition is made dramatic by the use of thick impasto and violent colour, through which run irregular rhythms and sudden flashes of light. An equal intensity and strength of colour is maintained in all parts of the painting, and consequently there is no gradation or effect of depth. The atmospheric values become of secondary importance, the forms are summarily sketched in and the stylistic value is lost.

84 A Sluice on the Stour, 1830-6. Oil on paper, 21.9×18.7 cm. London, Victoria and Albert Museum. This is one of Constable's last paintings, where a search for the 'effects' of nature has taken the place of a study of the 'aspects' of nature. The brush-strokes are agitated and uneven, lacking in depth and continuity.

85-6 Sketch for the Valley Farm, c. 1835. Oil on canvas, 25.4×21 cm. London, Victoria and Albert Museum. This is one of the studies Constable prepared for the large painting exhibited at the Royal Academy in 1835 (purchased by R. Vernon and now in the Tate Gallery). This painting is the last fully completed work he executed on the basis of the sketches made on the Stour.

Stonehenge, 1835 (*ill. in black and white on p. 23*). Watercolour, 38.7×59.1 cm. London, Victoria and Albert Museum. The ruins of Stonehenge in southern England are the remains of an ancient temple built about the beginning of the second millennium B.C. and dedicated to the cult of the Sun. It became a place of pilgrimage for all England and much of northern Europe, and was rebuilt and enlarged during the Bronze Age, about the fifteenth century B.C. The monument must certainly have been an imposing sight, and even today the majesty of these megalithic remains endures. This watercolour, exhibited at the Royal Academy in 1836, is a famous and much discussed example of the production of Constable's last period. English landscape of the time – especially that of Bonington and his followers – had taken an entirely different direction, except for the lyricism of the paintings of Turner. The only cultural influence which can be discerned in this painting is probably Girtin's. But in all other respects Constable's originality is absolute: the dramatic impact and imaginative qualities predominate. In this sketch Constable completely broke away from the traditional paintings of ruins, not only in the general conception of the composition, but also in his technique and use of colour. A highly dramatic effect is obtained from the cold tones of the sky, cut across by blinding flashes of light which illuminate the whole scene in a metaphysical glow. On the other hand, it cannot be denied that this painting is imbued with a certain tendency to romantic rhetoric.

87 The Cenotaph of Cole Orton, in memory of Sir Joshua Reynolds, 1836. Oil on canvas, 132×108.5 cm. London, National Gallery. From a drawing dated 28 November 1823 (now in the Victoria and Albert Museum). This painting is symptomatic of Constable's late manner, tending to a large extent towards the mannerism of romantic painting, which had by then penetrated throughout Europe. As Argan observed, ' in the 1830s (he died in 1837) Constable was concerned to bring his paintings to a greater degree of " finish ", reviewing the ideas of his whole lifetime and often working at a level one might call " academic " '

Besides this academic technique, as pointed out by Argan, we cannot fail to notice the rhetorical taste of the time being reflected in paintings like this: the dark tones of autumn, the desolation of the advanced season, the memorial column. Some people believe – probably with justification – that the stag was added ' in order to bring a touch of life to the composition ' (M. Chamot). These negative judgments are not, strangely enough, shared by Arcangeli, who considers *The Cenotaph* a ' prestige painting '.

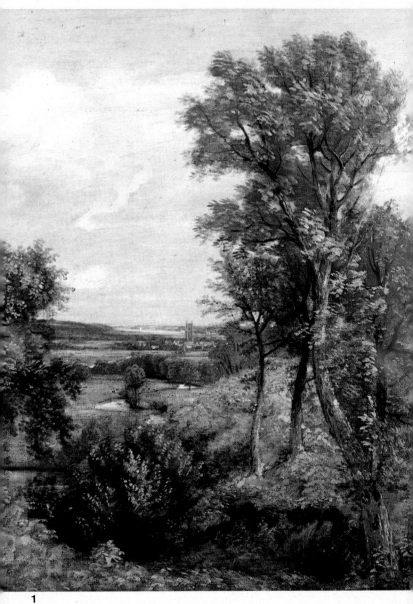

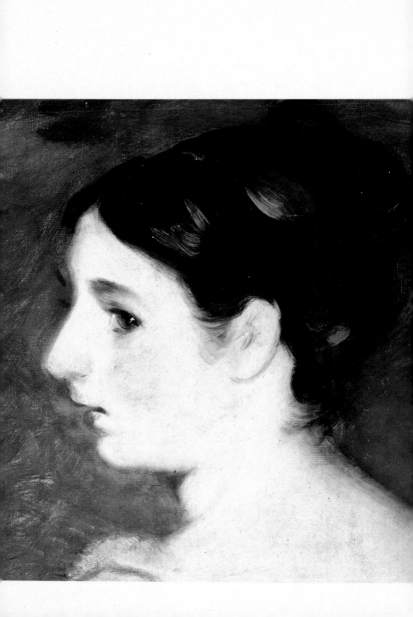

3

4

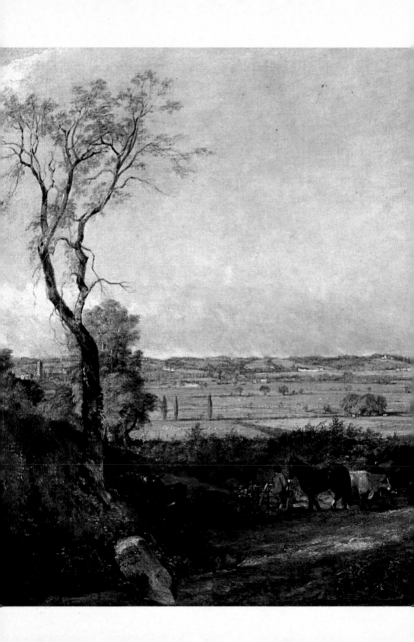

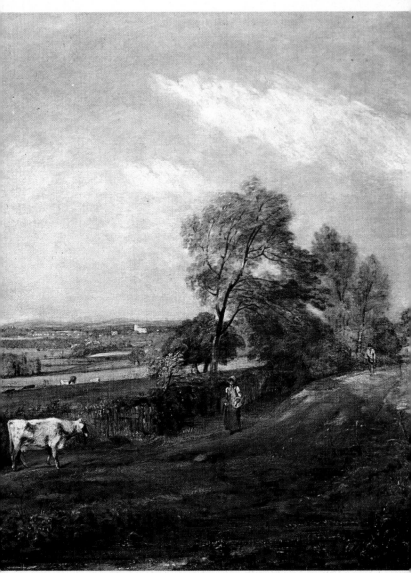

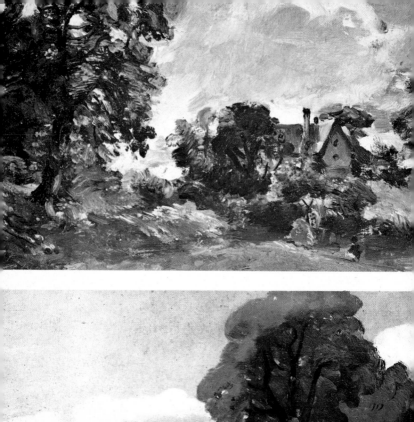

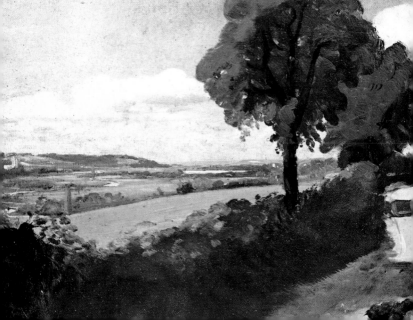

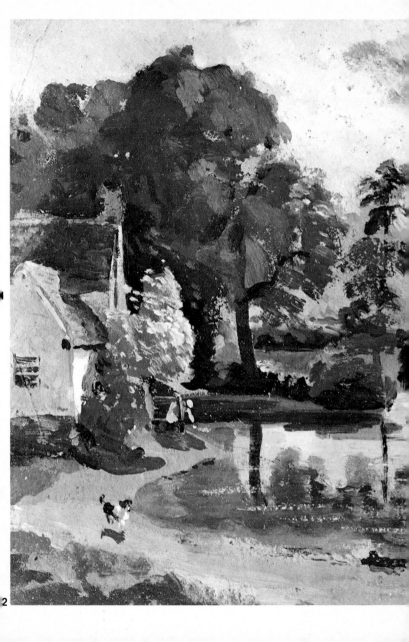

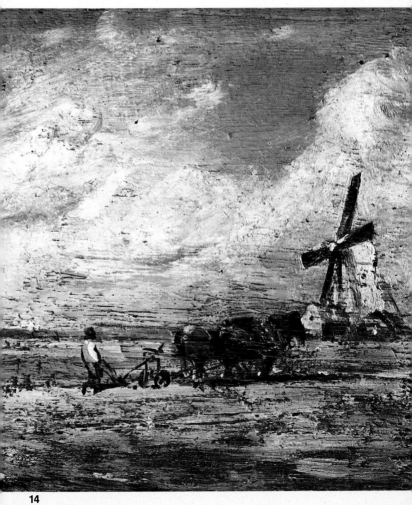

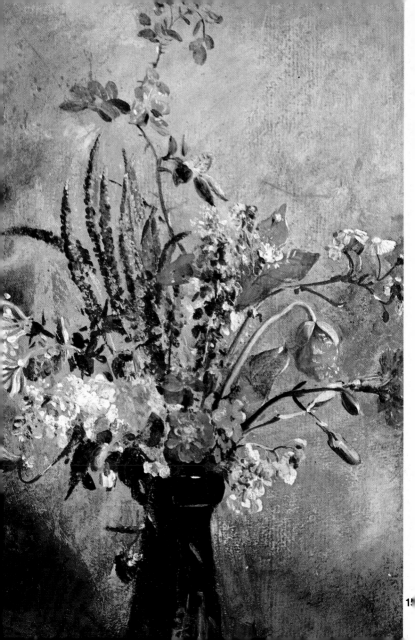

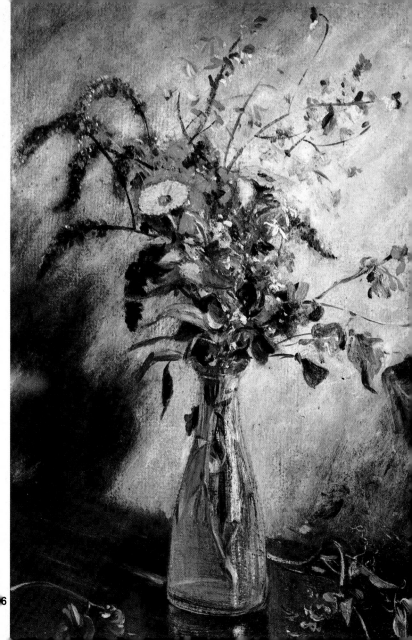

17

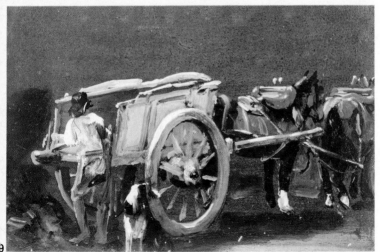

9

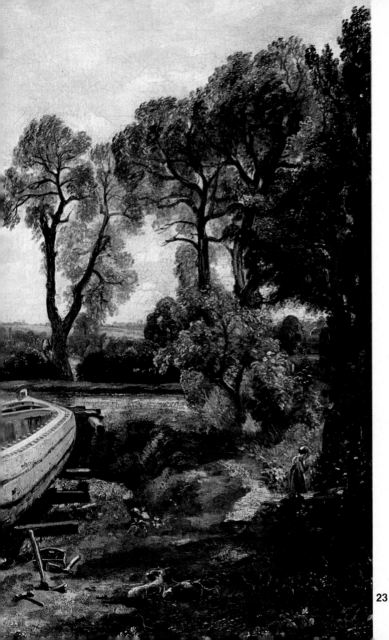

23

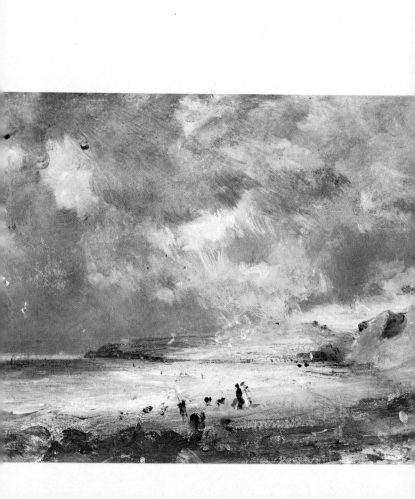

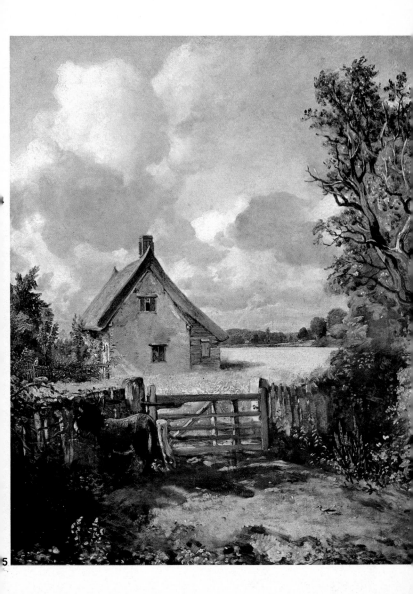

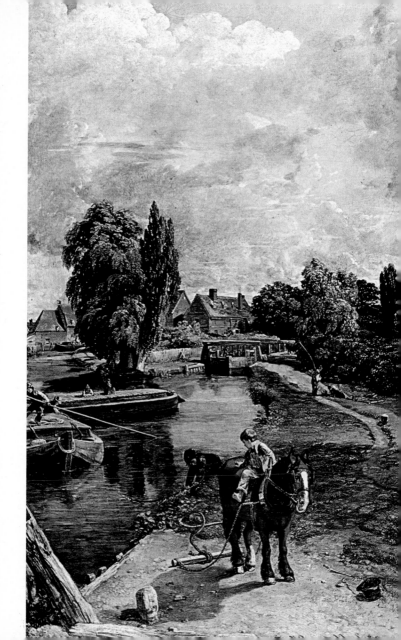

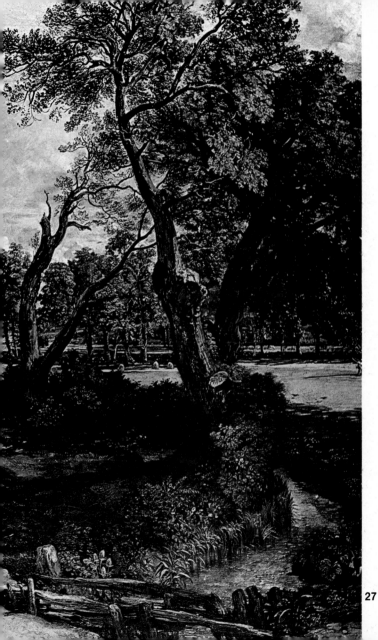

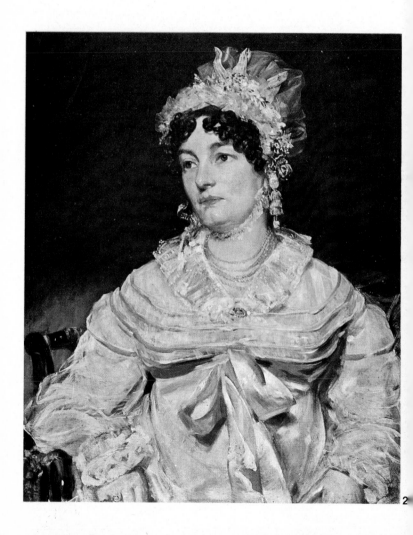

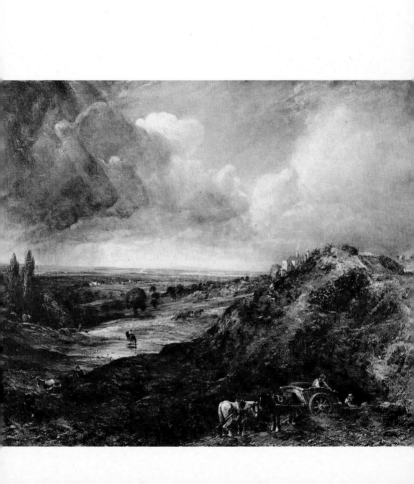

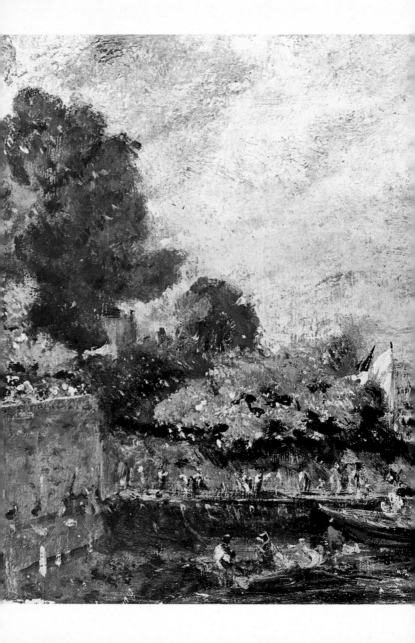

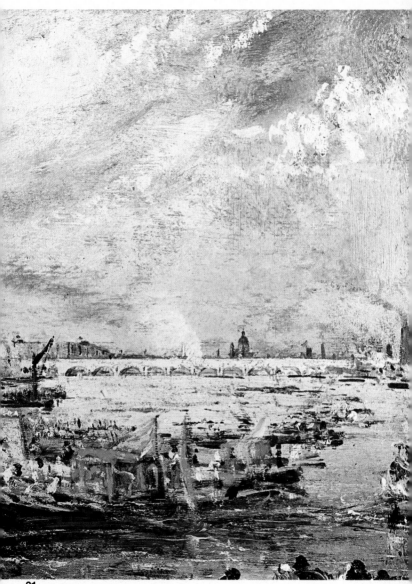

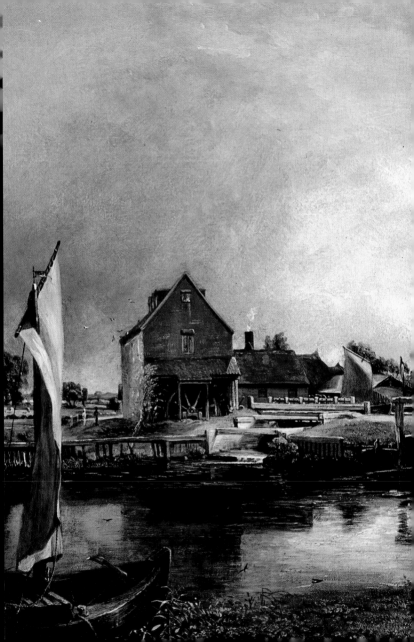

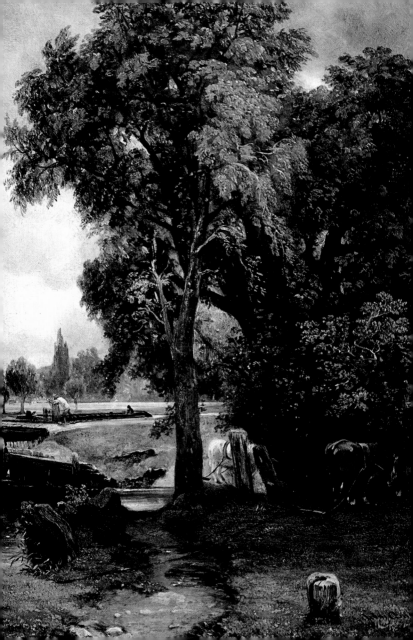

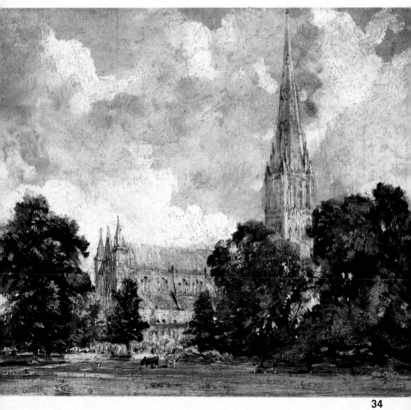

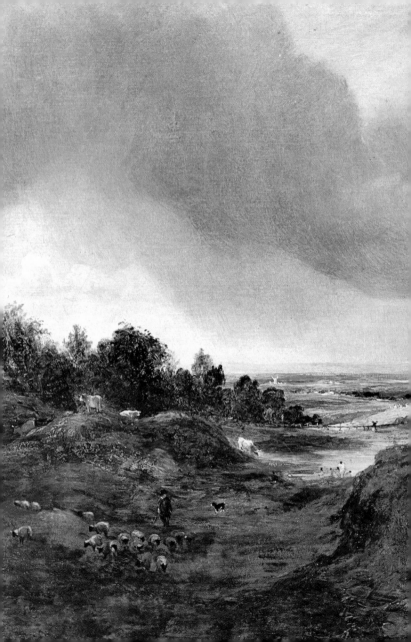

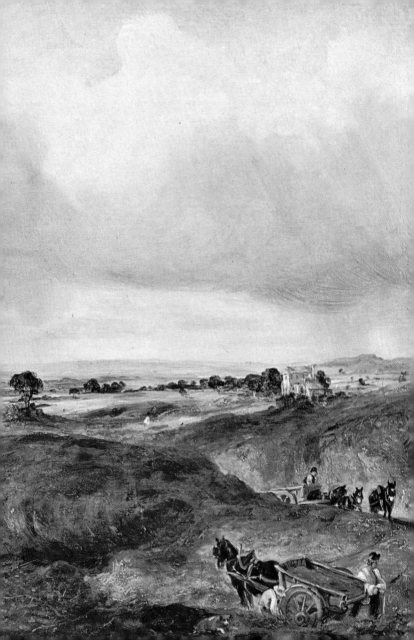

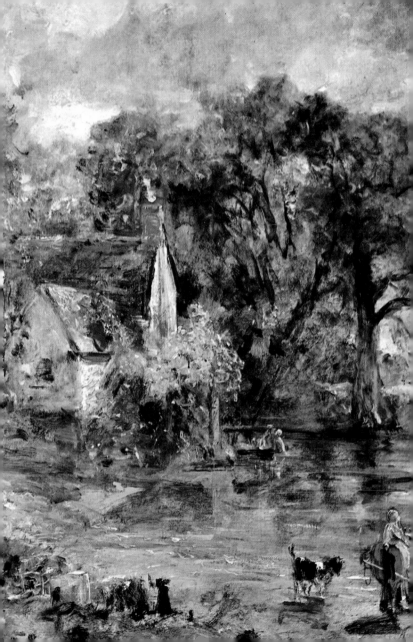

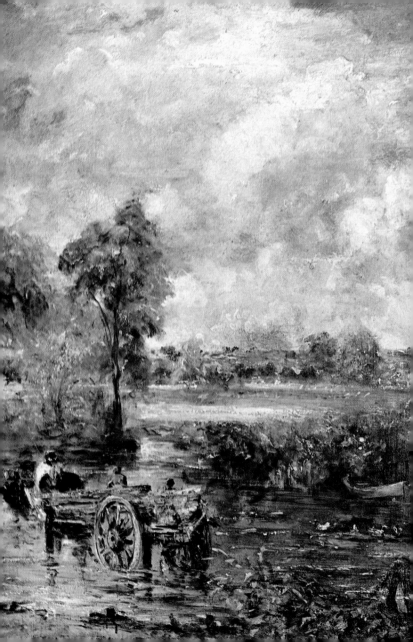

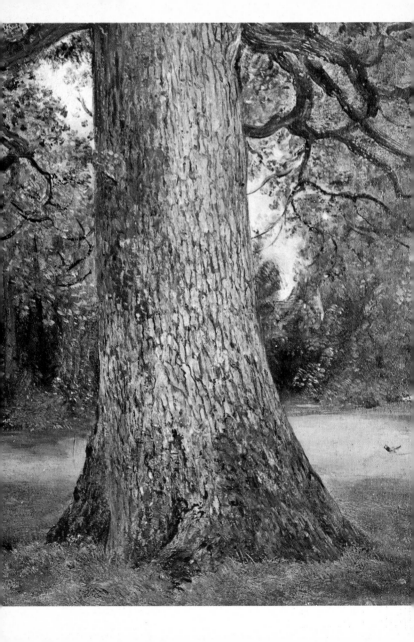

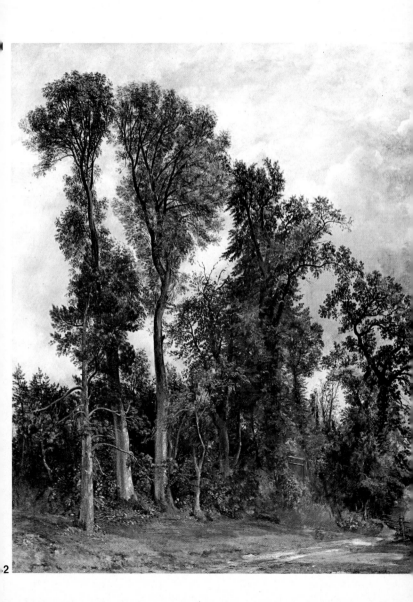

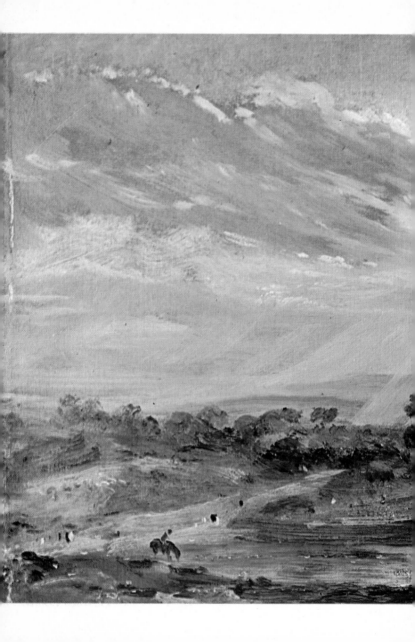

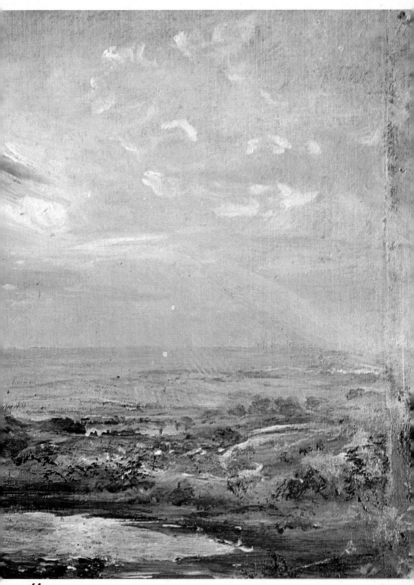

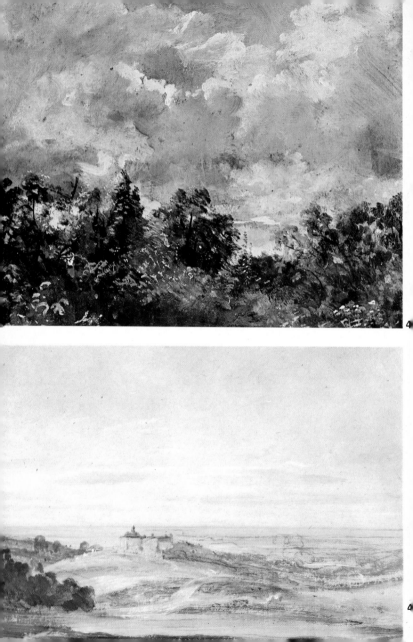

4

4

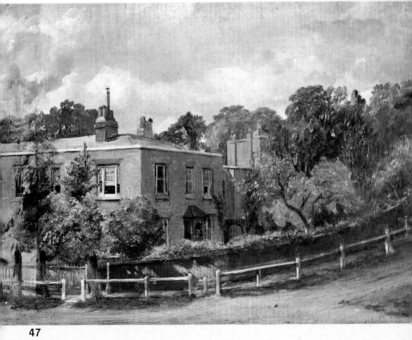

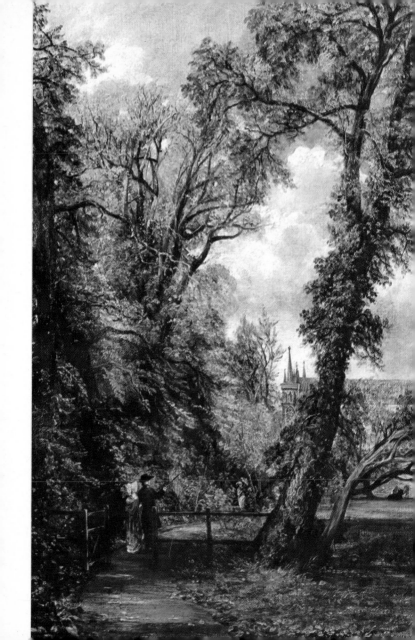

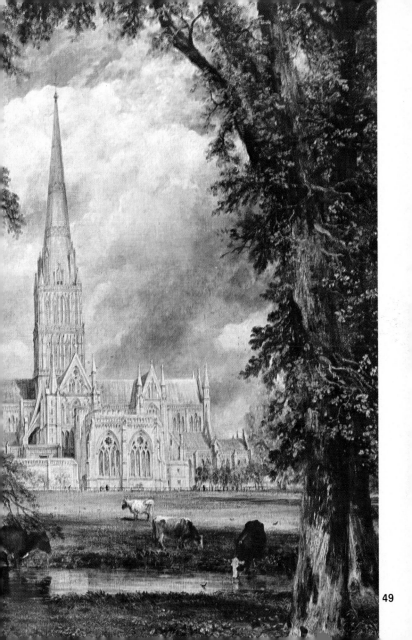

49

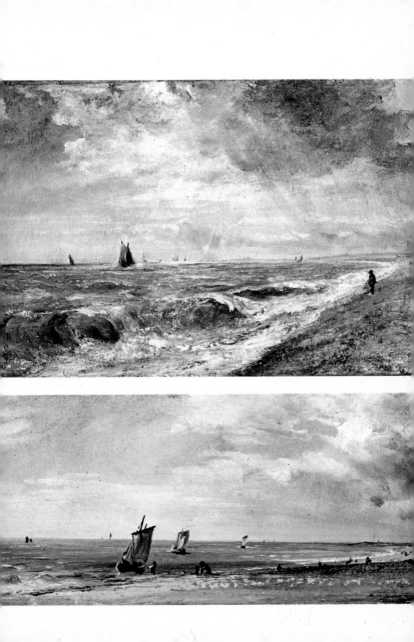

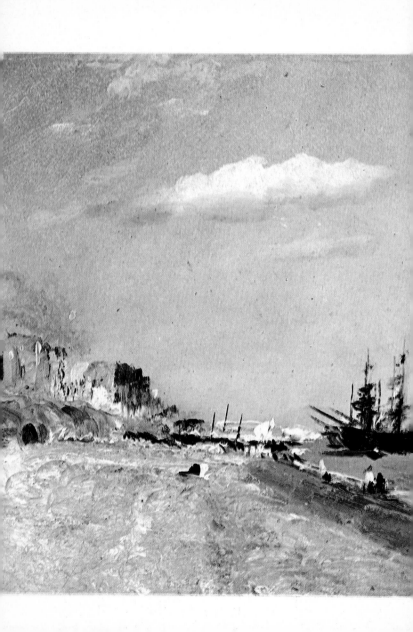

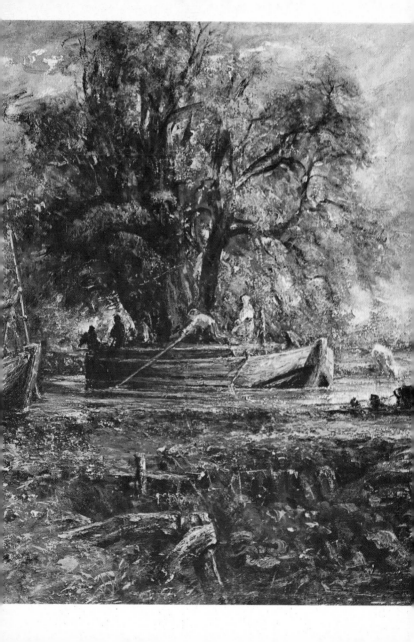

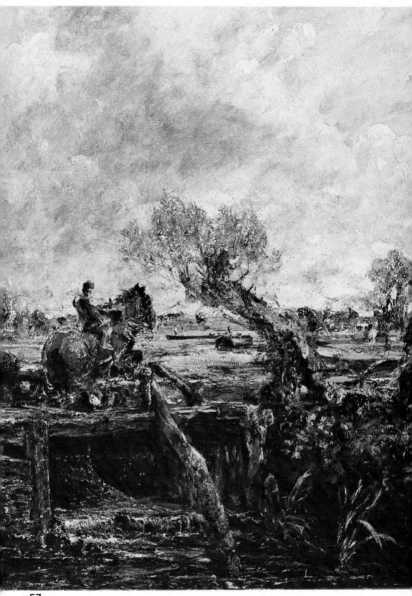

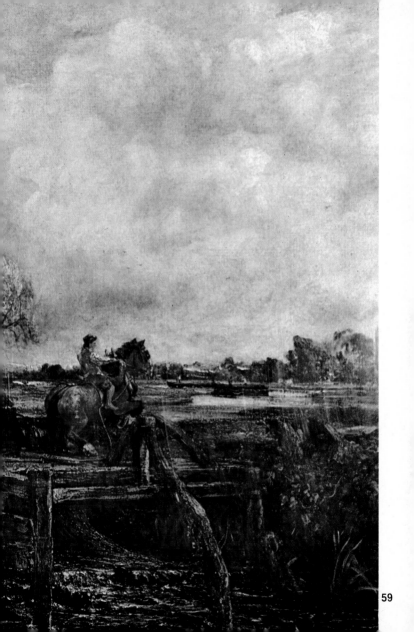

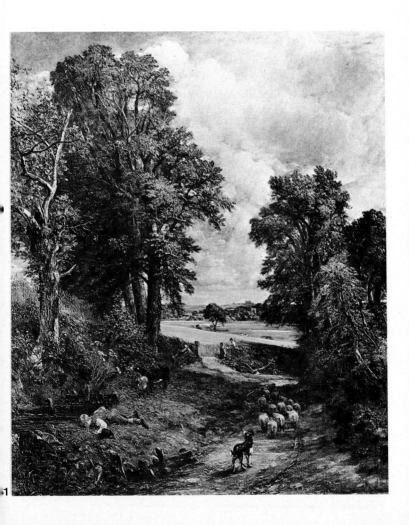

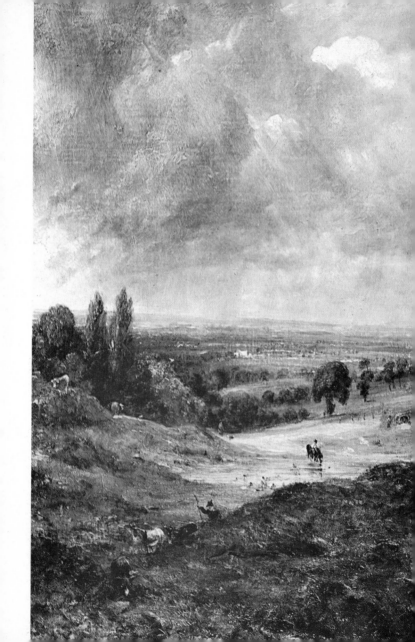

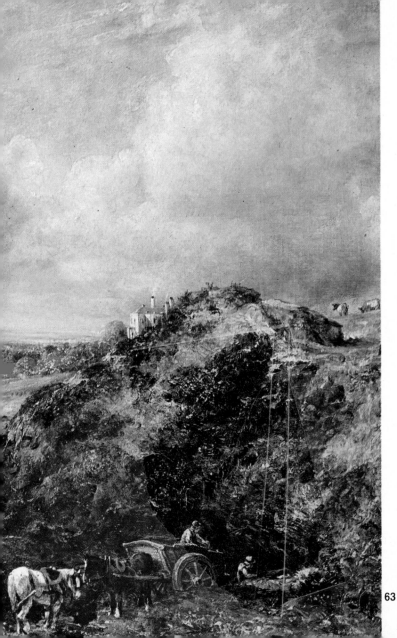

63

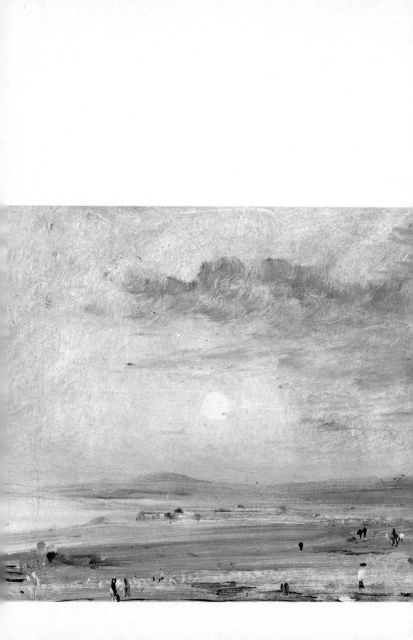

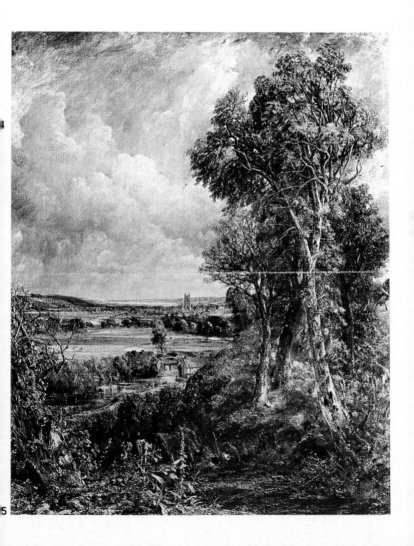

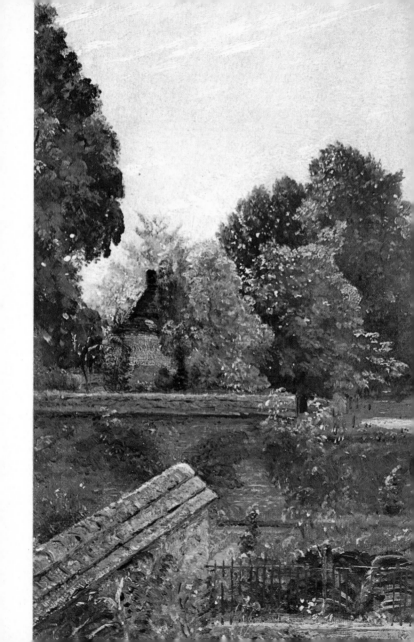

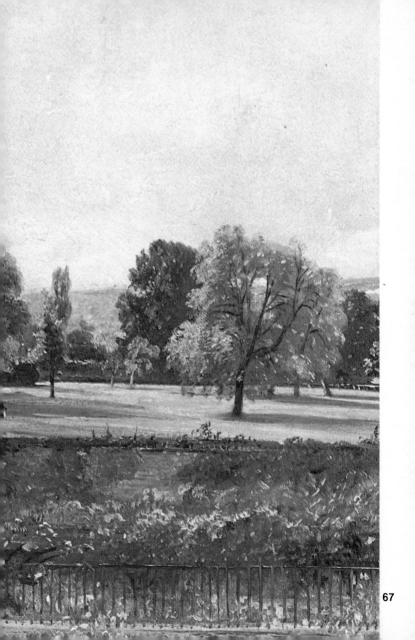

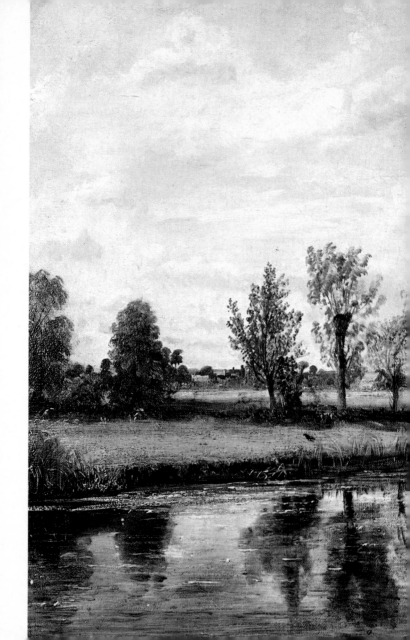

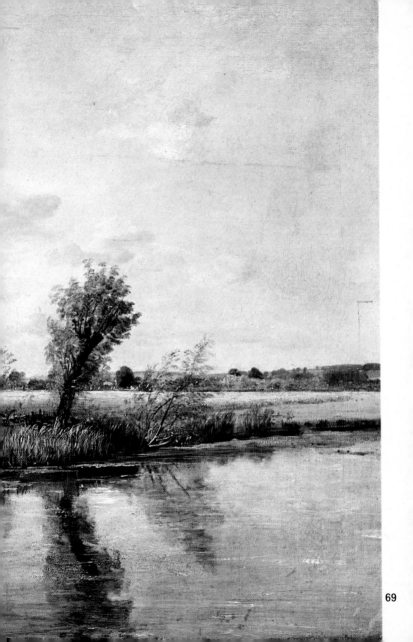

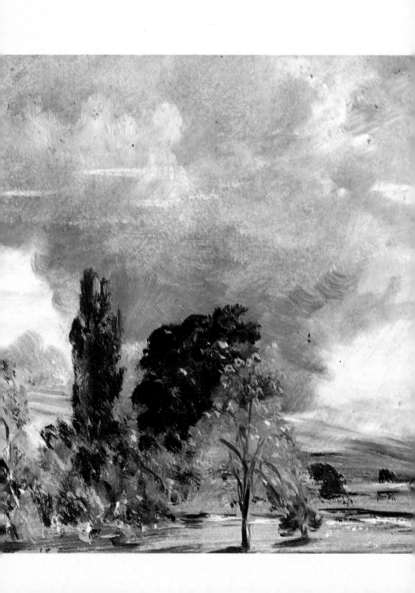

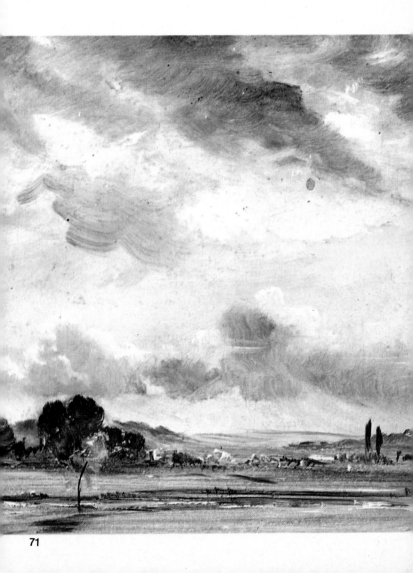

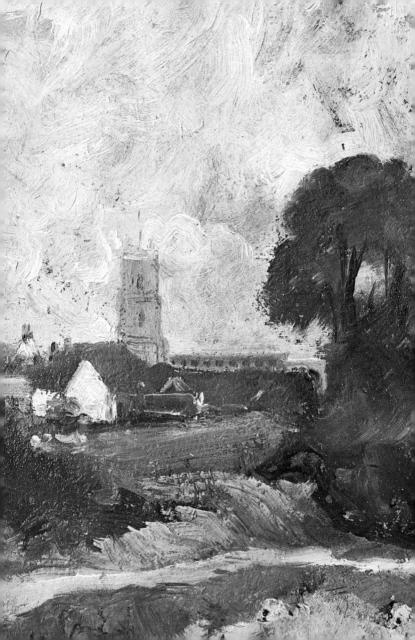

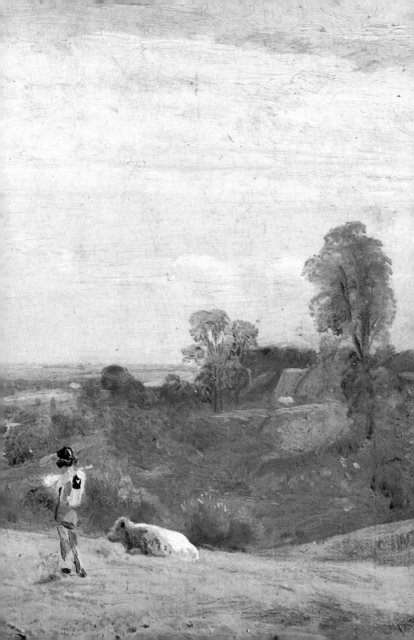

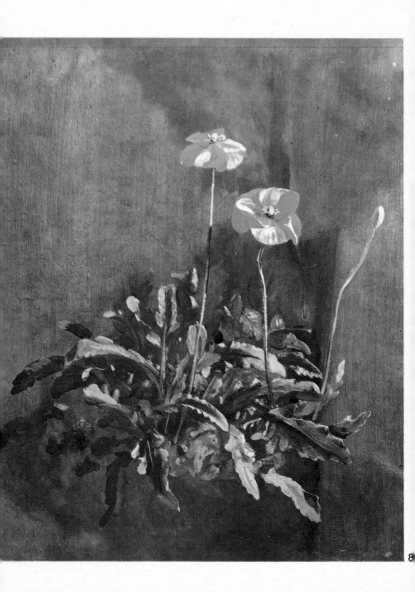

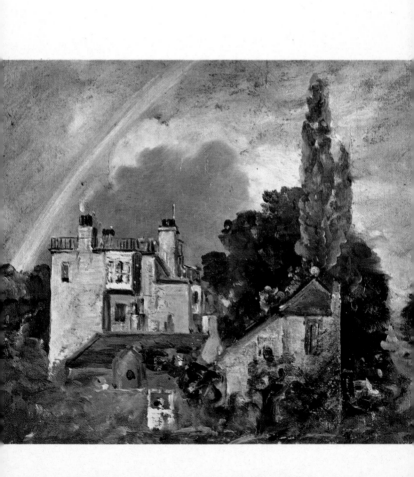

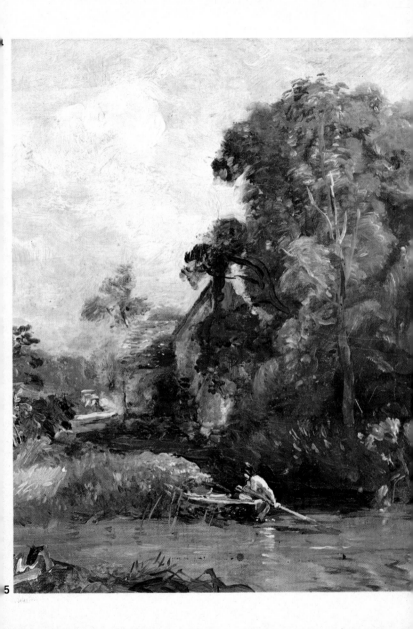

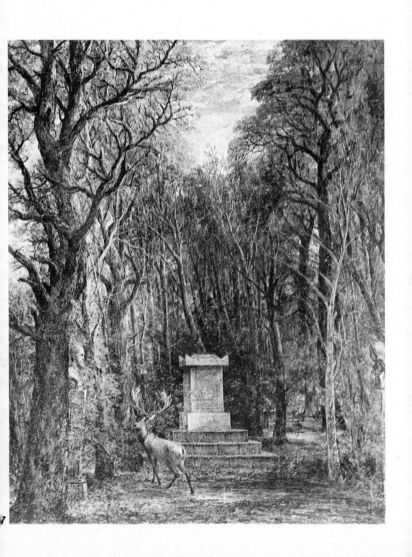